SCULPTING IN
COPPER

Sue White-Oakes

SCULPTING IN COPPER

Jim Pratt

Sue White-Oakes

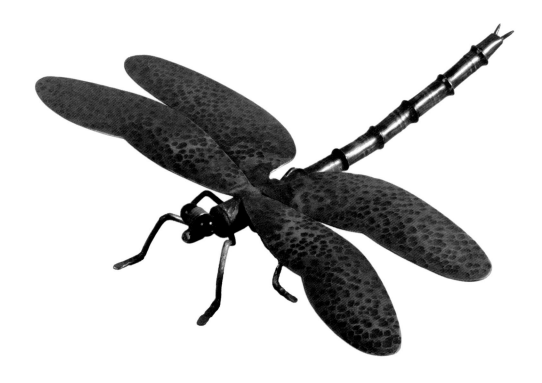

BLOOMSBURY

LONDON · NEW DELHI · NEW YORK · SYDNEY

DEDICATION

We would like to dedicate this book to Peter and Jean Goodfellow of the Lost Gallery, Strathdon, Aberdeenshire, for their enthusiastic support of Sue's copper sculpture over the last sixteen years, and to Graham Whistler, FRPS, without whose guidance Jim's photographs would not have been taken.

First published in Great Britain 2013
Bloomsbury Publishing Plc
50 Bedford Square
London WC1B 3DP
www.bloomsbury.com

ISBN: 978-1-4081-5243-0

Cover design: Sutchinda Thompson
Page design: Susan McIntyre
Editor: Kate Sherington

Typeset in 10.5 on 14pt Celeste

This book is produced using paper that is made from wood grown in managed, sustainable forests. It is natural, renewable and recyclable. The logging and manufacturing processes conform to the environmental regulations of the country of origin.

Printed and bound in China

Right: Sue White-Oakes, 'Seahorse', 1989.
Copper, 80 cm (31½ in.).
Photo: courtesy of the artist.

Contents

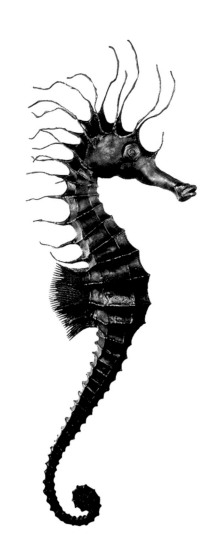

Introduction

Copper was the first metal to be used by man, and is still one of the most widely used of metals, having been worked for 4,000 years. Although methods of beating and bending it into complex shapes are still used (for example, in the manufacture of garden sculpture, jewellery and domestic utensils), it is often classed as a base metal and is rarely included on its own in fine decorative arts. However, it is a metal readily available and is well suited as a medium of artistic expression, being relatively easy to work and resistant to corrosion.

The purpose of this book is to provide instruction and inspiration for sculptors at all levels on how to use copper. The figurative work of the sculptor Sue White-Oakes moves the use of copper from a 'craft' into an 'art', and provides a means of reviving interest in one of humanity's oldest metalworking skills. Inevitably, the work is also a celebration of a lifetime's ingenuity and a lesson on techniques that shows there is no limit to your creativity.

We will focus on five progressively more complex pieces of sculpture designed by Sue and show you how to make them. The techniques, and the range of tools needed for each, are illustrated. In the final chapter, we will then look at other artists' work in this metal. We hope this book proves to be a detailed and explicit guide on metalworking in art, which will inspire you to take your talent to the next level.

Sue developed her techniques working with copper on her own, over some 25 years. Although she had some experience of working with metals (she trained as an industrial designer), she had never worked in copper as an artistic material until 1985, after becoming involved in a domestic plumbing operation at her home in Scotland. It was after this was completed that she realised copper would allow her to express her love for the evolved refinement of the shapes of living creatures. In Sue's own words:

'While working in my studio, I picked up a dead beetle off the floor. At the time, I was working on a series of abstract sculptures based on industrial robots. Looking at the structure of the beetle under a magnifying glass, I was struck by its mechanistic form. It was beautiful, a perfect little robot, an engineering wonder. Its body was assembled from sheet material: tubular legs, curved body plates, wire feelers. Having worked with metal all my life, it suddenly struck me that I could make a sculpture of this beetle, and that sheet metal would be the ideal material.'

Sue's work has progressed technically from that relatively crude representation to more sophisticated pieces, such as the owl (see Chapter 6, p. 107).

Copper has significant advantages for those wishing to take up some sort of metalworking art. First, it is readily available in various forms within the building and plumbing trades (as sheet for roofing, wire for

This was the first of Sue White-Oakes' figurative sculptures in copper, made in 1985 with scraps of copper left over from a domestic plumbing project.

electrical work and pipes in plumbing). Second, it can be purchased in most countries throughout the world.

New copper can be expensive: recycled, it may be obtained cheaply. Even new, it is much less expensive than, for example, silver, with which it shares some of its working properties. Another attribute is the ease with which copper can be worked. Properly annealed (heated), copper is soft and pliable, and can be bent or beaten into complex shapes. It is also forgiving: it can be annealed and work-hardened over and over again. Thus, none need be wasted. Copper is worked at much lower temperatures than, for example, iron and can be wrought in modest spaces. It is ideally suited to being joined, by brazing and soldering, using simple techniques familiar to most plumbers.

Finally, copper is stable, it will not rust and, once patinated, it is very resistant to discolouration and corrosion. Some of the earliest surviving metal figurative art is in copper, from the Middle East. This 20 cm (8 in.) head of a lion, pictured opposite, was fabricated out of sheet copper over a bitumen core. It was made in southern Iraq 4,500 years ago.

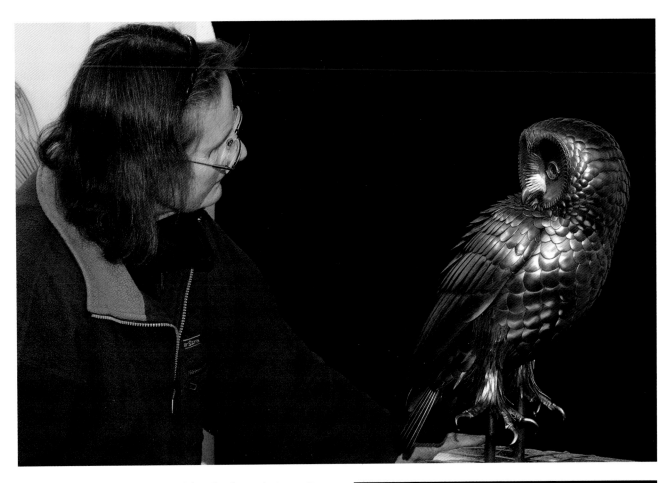

Compared to the dead beetle, the techniques Sue needed to make this sculpture of a Tawny Owl in 2009 represent 25 years of trial and error. Having mastered the technical art of melding copper into the shapes she wants, Sue can concentrate on expressing in metal her deep understanding of the relationship that has evolved in nature between function and form, in this case, through the representation of a top predator.

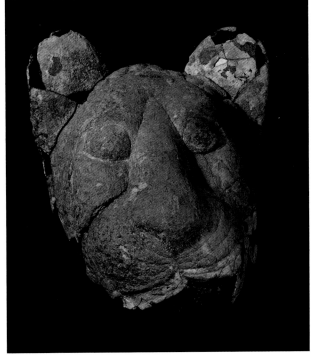

The lion's head, originally made from a copper sheet beaten into shape over a bitumen former.
Photo: © The Trustees of the British Museum.

The detail on these 30-mm (1¼-in.) diameter copper coins illustrates the capacity for fine modelling in copper using steam-driven coin presses. Ostensibly to provide low-value coinage for workers, these tokens also advertised the technological skills of the companies that made them, and as such were a form of decorative art.

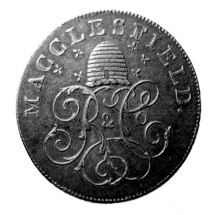

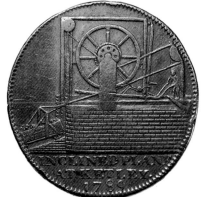

Below: Sue White-Oakes (pictured here) maintains an interest in the fashioning of copper wherever she goes; in this case, on a pavement in Kashgar, western China, in 2000. The coppersmith squats cross-legged, an anvil in the ground in front of him, on which is a bowl he is raising using only the wooden mallet and the raising hammer by his side.

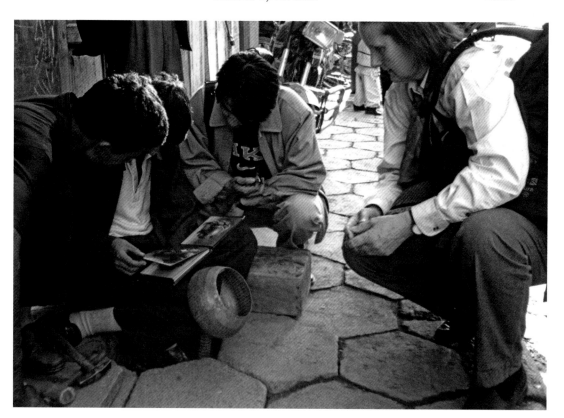

More recently, copper was used to create these tokens (left), used as currency in newly-industrialised Britain in the 18th century.

The art of working copper to make kitchen utensils, such as deep bowls, using the simplest of tools, continues to this day.

This book is divided into three sections. In Chapter 1, we consider the material, its availability and describe basic techniques on how it can be cut, softened, shaped, joined, cleaned and polished, and show which tools are needed for each technique.

Chapters 2–6 make up the second and main part of the book, taking you step-by-step through five increasingly complex projects, starting with a simple bowl in Chapter 2 (where no soldering is required), through to the making of a two-dimensional table decoration based on fallen leaves (Chapter 3). In Chapter 4, we demonstrate the making of a three-dimensional free-standing sculpture of an insect (a dragonfly), which introduces some techniques for handling copper pipe and copper wire. Chapter 5 is more ambitious: it is an exercise in planning, in precise working and in imagination. It requires the raising and joining of two elliptical-shaped plates from copper sheet to form the sides of a fish, and decorating it.

The last chapter of this section, Chapter 6, shows how Sue created, over many months, a large free-stranding sculpture of a Tawny Owl. This is an ambitious project which demonstrates the skills that can be brought to bear to transform recycled copper into a lively and vital creature. Because this is not a beginner's piece, we do not aim to demonstrate how to build a replica: rather, we wish to show how and in what sequence it was made, and with what techniques, with the aim to stimulate your imagination and reveal how complex sculptures can be made from copper.

In the third and final section of the book, Chapter 7, we end with a gallery of photographs of the work of other artists working in copper, along with a few more examples of Sue's figurative work.

Since the basic techniques we describe in Chapter 1 are needed for each project, we make no apology for some repetition of these techniques in the descriptions in Chapters 2–6. We believe that to do so adds clarity to the descriptions themselves, and also demonstrates how the techniques change both within and between projects. So, to some extent, each project is self-explanatory and stand-alone. Nevertheless, we would urge you to read Chapter 1 carefully, and to familiarise yourself with the techniques by practising with scrap before embarking on serious work.

It is possible to start working in copper with a few well-chosen inexpensive tools obtained from a good tool shop, or from second-hand tool shops, market stalls, junk shops and scrap yards. Many you can make for yourself. Moreover, you can use scrap copper left over from building or plumbing work, also obtainable from your local scrap yard. Nor do you need an expensive studio: the first three projects were all made on a benchtop of less than 1 square metre.

Most importantly, we hope you will enjoy this book.

Materials, methods and tools

INTRODUCTION

In this chapter, we list the materials needed for the projects described in the rest of the book, and show you the basic set of tools you will need to make a start with this form of metalworking. We then consider the essential methods used to cut, anneal, shape, join, colour and polish copper. We include within the chapter a few 'tricks of the trade', which Sue has designed and developed to help her make a wide variety of pieces in this unusual form of sculpture.

MATERIALS

COPPER (Cu)

COPPER SCRAP

All you need to get started is a selection of copper scrap from your local scrap or plumber's yard. Choose a small local yard, since large ones are less likely to let you buy direct from them. Take a large, strong plastic bag with you to carry your selection for weighing. You should be able to source copper in the form of sheet, tube and wire. You may also be able to buy an old hot water tank and old copper tubing direct from a local plumber. You can cut the tank to provide you with some useful sheet, and sell the top and bottom to a scrap merchant.

NEW COPPER

Sheet is available in various thicknesses, from 0.3–10 mm, 1–2 m ($23\frac{1}{2}$–$47\frac{1}{4}$ in.) in length and in at least three grades from soft to hard. The majority of the work described here was made using sheets in the range of 0.5 mm to 1.2 mm thick, the thicker sheet being used in those areas where strength or extra stiffness was required. For example, the tail feathers of the Tawny Owl are made using thicker copper because this is the part of the sculpture by which it will be carried.

Copper wire is available (hard or annealed) in various diameters ranging from 1.4 mm to 8 mm. It can, of course, be recycled from electrical wiring, especially from heavy-duty, industrial applications.

Rods and bars are available in various lengths and diameters (up to 6 m, or 19 ft 8 in. long, and up to 175 mm, or 7 in., in diameter).

Tubes and pipes are available new in a variety of sizes (6–80 mm outside diameters), thicknesses and lengths.

SOLDER

The solder recommended is an alloy of *brazing filler metals*[1], supplied as Silbralloy™ from Johnson Matthey Metal Joining Plc.

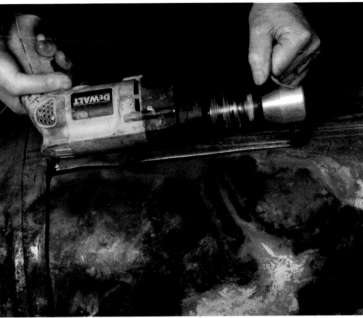

Copper is available as sheet, tube, wire and bar. It can be bought new or as scrap from a scrap yard. The most useful thicknesses of sheet are 0.7 mm, 0.8 mm and 1 mm.

Hot water tanks are an excellent source of copper sheet. This one is being cut using a 'nibbler' attached to a power drill. Nibblers are not expensive and save a lot of effort. Tanks can also be cut up using a sharp, wide brick chisel.

Silbralloy™ does not require flux when it is used to join copper to copper. It is widely used in refrigeration, heating and air-conditioning industries for capillary-type joints. The materials that make up this solder are not hazardous in themselves. When heated and used as 'brazing filler metals', fumes of metal oxides could be evolved but are unlikely to exceed WEL (workplace exposure limit) under normal conditions. However, if overheated, potentially harmful fumes might be released. Advice on appropriate ventilation and suitable face masks should be obtained from the supplier. Fire suppression by foam, carbon dioxide or water spray is recommended.

For joining other metals, including ferrous, Easy-flo™ 55 (cadmium-free) is used. Like Silbralloy™, it is made by Johnson Matthey Metal Joining Plc in rods of 1.5–3 mm diameter, and can be bought direct from the company. It can also be obtained in smaller quantities from welding equipment shops and jewellers' suppliers.

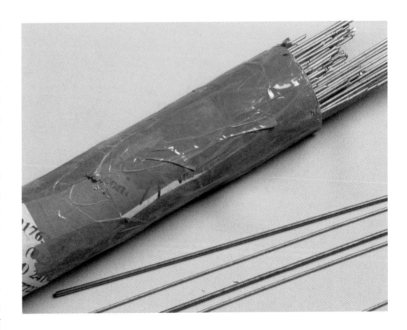

Silbralloy™ solder is purchased in the form of rods. The rods are available in various diameters: 2 mm, 2.5 mm and 3 mm, x 600 mm (23½ in.) long. We recommend buying 3 mm to begin with.

It is used to join all the common engineering metals, including stainless steel, but requires a flux such as Easy-flo™ flux powder.

GAS

The metals are heated by means of a blow torch, using propane at a constant pressure. The torch may screw directly on to a small cylinder or be connected to a larger cylinder via a flexible pipe. A larger cylinder is more economical, easier to use and can be conveniently stored on a mobile trolley.

An example of a torch that is attached to a large cylinder of gas by a flexible hose is the Bullfinch™ Autotorch Brazing System, which can produce temperatures up to 950°C (1742°F) under normal conditions, and is particularly suited to hard soldering of copper. The torch can be supplied with three burners or nozzles, each of which has a different width of flame. They all

burn at the same temperature with the wider nozzle consuming the most gas.

HEALTH AND SAFETY

The most obvious hazards are those involved in the handling of hot metal and in the use of naked flames. Using leather welding gauntlets and tongs reduces the risk of burns.

When concentrating on the annealing process, it is easy to forget how hot the metal becomes, and attempting to quench it with ungloved hands will give a nasty burn. Always use gauntlets and tongs for quenching: get into a routine from the start and keep them handy. The gauntlets shown opposite are sold as welding gloves and are widely available. The long tongs are homemade. The pliers (known technically as bent snipe nose pliers) are very useful for manipulating small, hot items. They are cheap and are readily available from

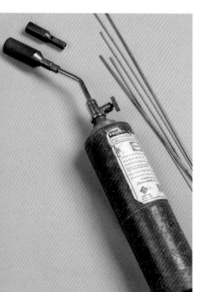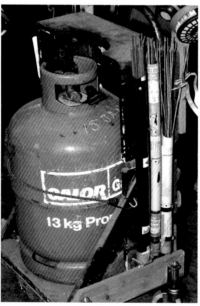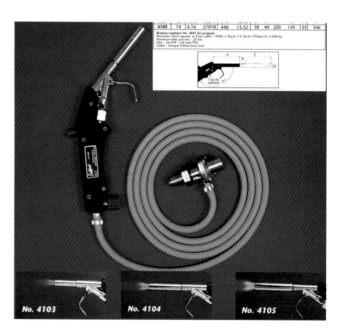

Left: A torch that screws directly on to a handheld cylinder of propane provides a convenient source of heat for smaller pieces of sculpture.
Right: Larger pieces of metal are better heated with propane using a burner connected to a larger cylinder by means of a flexible hose.

Bullfinch™ provide three nozzles for their Autotorch Brazing System, the narrowest (A4103) being best suited to heating limited areas of metal (for example, prior to soldering) and the widest (A4105) covering a wider area (for example, for annealing).

tool suppliers. When quenching, always make sure that the supply of water is adequate for the size of the piece being quenched, that the water is within easy reach and that the route to the water is not obstructed.

When using blow torches, be aware of the manufacturer's precautions that should accompany a newly purchased torch. You will be using a highly inflammable gas, which burns at around 2000°C (3632°F), with a flame 10–20 cm (4–8 in.) long. The precautions should cover *general safety rules; assembly, operation and ignition; flame adjustment; shut down and storage* with any *warning notices* attached. **Please read them all**. With a bit of thought, it is not difficult to organise your work space to reduce the hazards of naked flames and hot metal. For example, it is essential to use a heat-insulating kiln brick on the welding bench.

TOOLS

The essential processes involved in metal-working with copper are:

- cutting
- annealing
- shaping (raising)
- joining (soldering)
- cleaning
- colouring
- polishing.

The basic methods used in each process are described in this chapter and illustrate the use of the tools, many of which are standard in sheet metalworking, for example car body repairs. There are some tools which we consider to be essential, namely a bench, a vice and a soldering place. The tools are not large, nor do they need to be expensive.

BENCH

A bench need not be large, however it should be rigid and firm. The bench shown over the page, for example, is 1 x 0.5 m (39½ x 19¾ in.) and was large enough

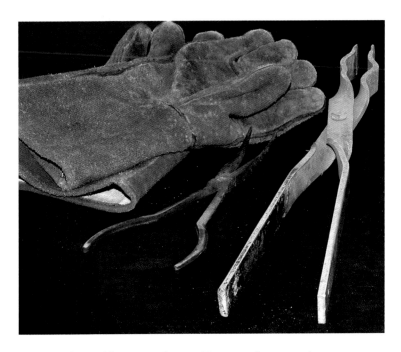

Leather welding gauntlets and homemade tongs, along with a pair of snipe-nosed pliers, are essential items in this work, since the temperatures reached in annealing or soldering often approach 1000°C (1850°F).

to accommodate the making of the bowl, the leaves and the dragonfly (see Chapters 2–4). This bench is on castors and would fit in a corner of a garage or garden shed. On the bench you can see a flat steel plate around 1 cm (½ in.) thick. This heavy chunk of metal is a useful addition to your benchtop, and provides an ideal base on which to hammer and true copper. You may be able to source one from a local blacksmith or even a recycling centre. Avoid cast iron, which is brittle and may shatter when hammered.

VICE

A vice in which sheet, bar, pipe or wire can be held firmly is essential. The best vice is an engineer's vice, firmly bolted to a rigid benchtop. A simple vice with straight jaws can be bought new for less than £50. However, second-hand ones are often sold for much less at car boot sales or markets. Make sure that there is minimal play when the jaws are opened or closed.

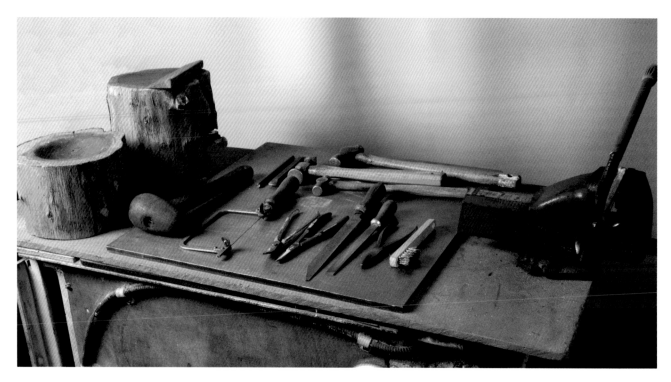

Assembled above are all the tools you need to cut, shape, true, clean and polish a simple piece like the bowl (Chapter 2), the leaves (Chapter 3) or the dragonfly (Chapter 4). Missing are the heat source and tools for handling the hot metal.

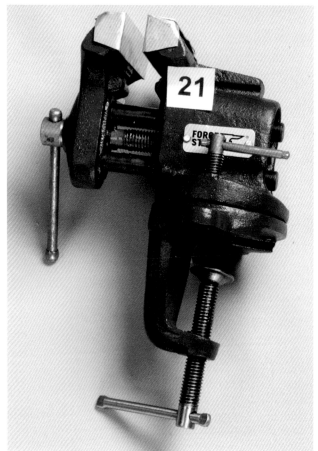

An engineer's vice is permanently bolted onto the benchtop shown above. Where circumstances only allow for a temporary set-up, and for small items only, a portable bench vice can be used.

An alternative to this semi-permanent fixture is a portable vice, which can be cramped on to the edge of a bench. Such a vice, suitable for light work, with 8 mm (3 in.) straight jaws and the facility to hold a pipe and to swivel can be bought new for around £25. The vice shown opposite has been fitted with simple slip-on aluminum jaw faces to prevent the marking of copper. The inside of the jaws should be smooth.

SOLDERING AND HEATING BASE

Equally important is a safe place on which to heat the metal. The best materials to use for this are lightweight (soft) insulating kiln bricks, used inside pottery kilns for insulation. These bricks are available[1] in a variety of shapes and sizes, can be cut with an old carpenter's hand saw and arranged on a metal tray on the benchtop to provide a safe place for annealing and soldering the copper. The tray can also be placed on a revolving modelling stand.

When making the owl (Chapter 6), two lengths of steel pipe were inserted into holes drilled in a double layer of these bricks to provide permanent support for the sculpture on the stand. Off-cuts from bricks are very useful for supporting or levelling odd-shaped pieces of copper for soldering (see p. 65).

MASKS AND EYE PROTECTION

When copper is heated during the annealing and soldering processes, copper oxides form on the hot surfaces. The most efficient way of removing these oxides is by wire brushing. However, wire brushing creates dust and to prevent inhalation an appropriate quality[2] respirator dust mask (FFP2 or P2) is recommended.

These thermal bricks make an ideal base for using the blow torch, since they are heat resistant and insulating.

[2] Disposable masks to European Standard EN:149 (FFP = filtering face piece, number = rating)

FFP1: Filters at least 80% of airborne particles with less than 22% inward leakage

FFP2: Filters at least 94% of airborne particles with less than 8% inward leakage

FFP3: Filters at least 99% of airborne particles with less than 2% inward leakage

Filters fitted to half or full-face masks to European Standard EN:143

P1: Filters at least 80% of airborne particles

P2: Filters at least 94% of airborne particles

P3: Filters at least 99.95% of airborne particles

[1] www.kilnlinings.co.uk

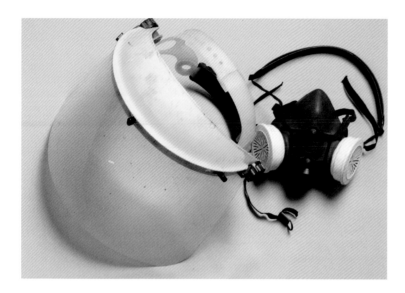

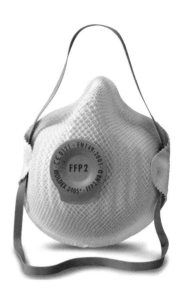

The best face and eye protection is a full-face shield. A respirator dust/gas mask, with replaceable filters of the appropriate type, is comfortable to wear and does not mist up the face shield.

This disposable dust mask provides protection against particulate dust.

Eye protection is also essential and a face shield is recommended. Soldering releases burnt gas residues and some volatiles from the solder itself. Whilst these are not hazardous substances, exposure over a long period should be reduced by ensuring good ventilation of the work area and by wearing a suitable gas mask. Details of appropriate gas and particulate masks can be obtained from reputable suppliers.

TOOLS

The wooden or metal tools needed for this work are neither complicated nor expensive. Alternatively, they are not difficult to make (for example, see p. 28). Not many tools are required; the collection shown on the benchtop (see p. 16) was sufficient to make the first three projects described in Chapters 2–4. A few more tools were needed for the fish (Chapter 5) and the owl (Chapter 6). Most can be obtained from good tool shops, especially those involved in plumbing, jewellery making or panel beating (for car repairs, etc.) and via the internet. Look on market stalls and in second-hand junk shops, where you should be

able to buy tools very cheaply. However, it is worth investing in a new pair of jeweller's tin-snips and a means of sharpening them, since so much of your work will depend on accurate cutting of sheet copper. Therefore, a note of caution: effective snips need adequate curvature. Since the amount of curvature on the jaws of this tool varies considerably, it is worthwhile going to some trouble to source a pair with a good curvature.

Local scrap yards or garages can be good sources of materials to make anvils: iron door knobs and trailer tow balls are examples.

Finally, although not a tool *per se*, we strongly advise that you collect odd pieces of scrap copper on which to practise your techniques.

Because most of the tools are common to all the projects, we have not provided you with separate lists needed for each. Rather, you will see them illustrated on the next four pages and throughout the rest of the book where they are shown in use.

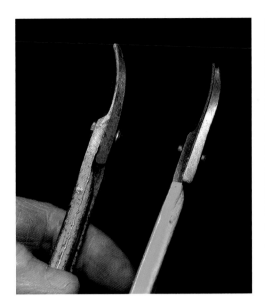

The choice of jeweller's shears (tin-snips) for cutting sheet is very important. The pair on the left are now many years old and are getting worn, but they still function well. However, the pair on the right, bought to replace the left-hand pair, are wholly inadequate as they have little curvature in comparison. Try to buy one pair of good quality curved snips and one pair of straight snips. The ideal size is 18 cm (7 in.) long.

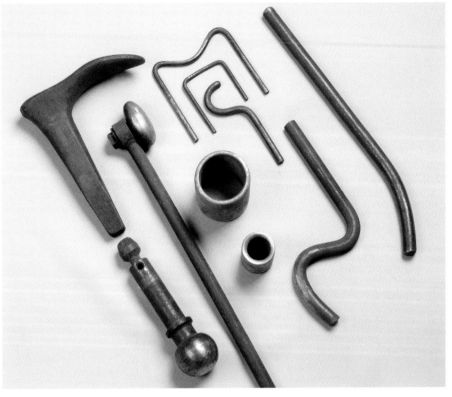

Homemade anvils: trailer ball, cobbler's last, solid brass door knob on a steel rod, metal tubes, selection of bent metal rods. Copper is quite soft to work so many metals can be used as anvils. All of these can be gleaned from a scrap yard.

These pieces of scrap are of great value to you to test your techniques, to learn about the properties of copper and to become familiar with your equipment. Remember, they can be bashed, bent and reheated as often as you want, yet will never be wasted.

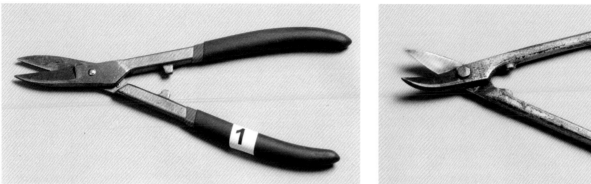

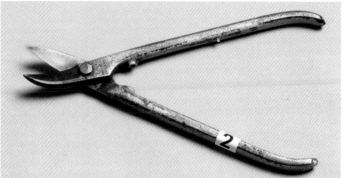

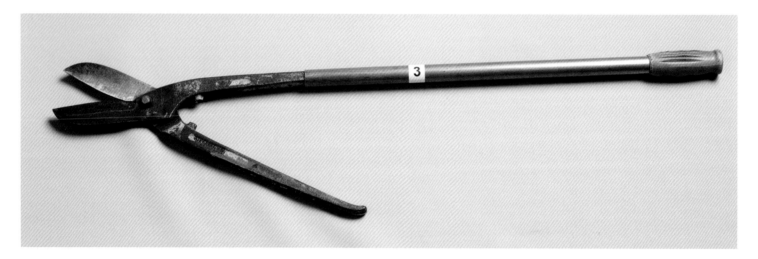

1. Jeweller's shears (straight jaws). These are for general cutting of sheet metal.

2. Jeweller's shears (curved jaws). These have curved jaws and are for cutting intricate shapes from sheet metal. The curved jaws make them very good for cutting into narrow places and around tight corners.

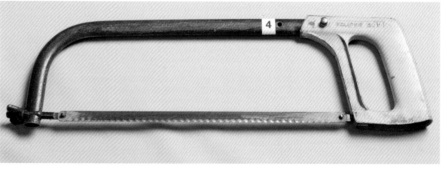

3. Large tin-snips (25 cm, or 10 in. long). These snips have been fitted with a tube to extend one handle, while the other handle is gripped in the vice to give better control and extra leverage when cutting sheet metal.

4. Hacksaw. For general use.

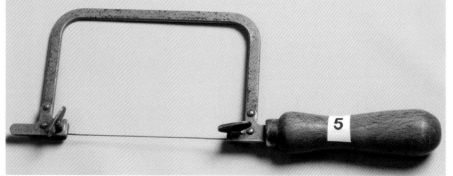

5. Piercing saw. A fine-bladed saw for cutting intricate shapes out of sheet metal.

6. *Square-headed wooden mallet. For truing copper sheet.*

7. *Planishing hammer. This hammer has one square flat face and one round flat face. Both faces have a very slight dome. The hammer is used for flattening sheet metal.*

8. *Small ball pein hammer (4 oz weight). For general use.*

9. *Bossing mallet (60–65 mm, or 2½ in. diameter head). This is used for beating hollow shapes out of sheet metal. It is usually made from box wood. This one is homemade. If you know a local wood turner, they could easily make one.*

10. *Large hammer (16 oz weight). For general use, including striking punches and chasers.*

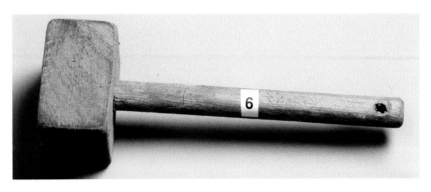

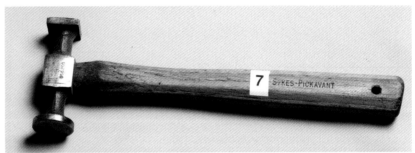

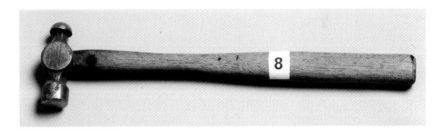

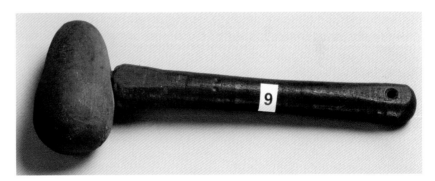

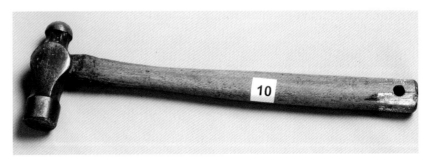

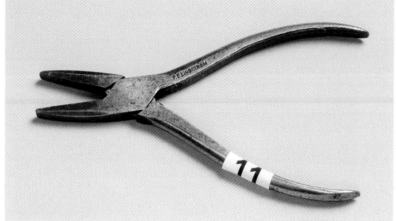

11. Flat-nosed box jointed jeweller's pliers. These are for gripping and folding metal. The box hinge joint makes them very strong, and keeps the jaws aligned so they do not twist out of shape.

12. Snipe nose pliers. Used for holding metal for quenching.

13. Metal file (fine cut). For finishing and final smoothing.

14. Metal file (medium cut). For general use.

15. Metal file half round (fine cut). For smoothing curves.

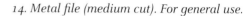

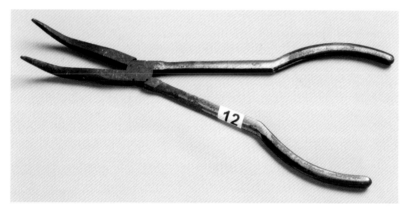

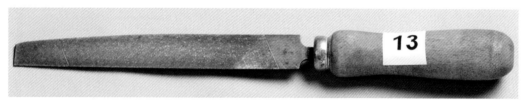

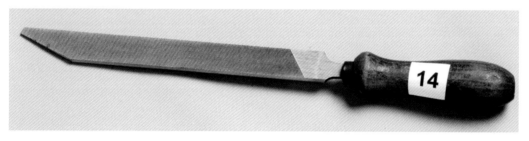

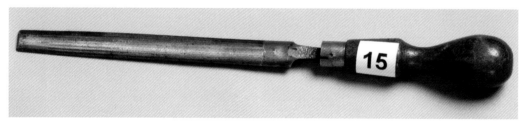

16. Round file (fine cut). For smoothing inside holes or tight corners.

17. Chasing tool. Made from a brick chisel. The sharp end has been filed smooth and given a slight curvature so that the corners do not dig in.

18. Swaging tool. Made from a steel rod set in a file handle, for belling out the ends of tube.

19. Wooden anvil. Made from a hardwood log with a depression carved into the top.

20. Wooden mandrel. A shaped block of wood secured to a steel tube which is held in the vice. Used for planishing bowl shapes.

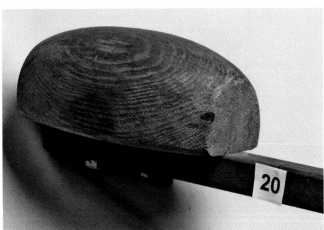

METHODS

CUTTING AND TRUING

Unlike conventional sculpture where, before casting in metal, a form is created out of clay that can be readily modified, retrospective changes are difficult to make using the appliqué techniques described here. Therefore, it is important to ensure that the parts are cut to the right size and shape from the start. This is simple with straight pieces, but less so when compound curves are involved, especially if the metal will be stretched. Cutting patterns out of paper or flexible card and testing them in situ helps, since minor changes in the shape can be effected rapidly. Transfer the shape to copper sheet of the appropriate thickness with a fine felt-tip pen, and cut to the outside of the line with shears. Smaller and more intricate shapes are better cut with curved jeweller's shears.

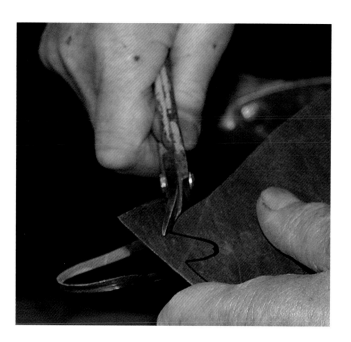

Curved jeweller's shears allow complex curves and tight radii to be cut with precision.

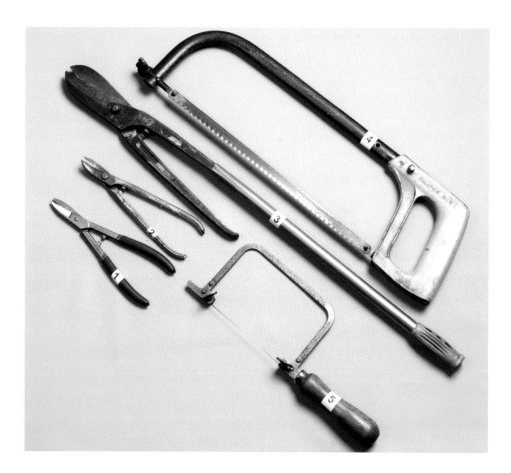

Jeweller's snips, straight (1) and curved (2); large tin-snips (3); hacksaw (4); piercing saw (5).

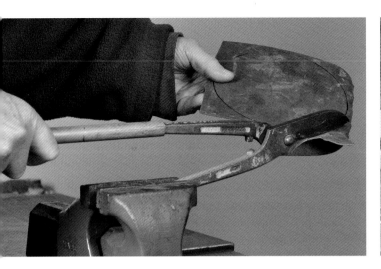

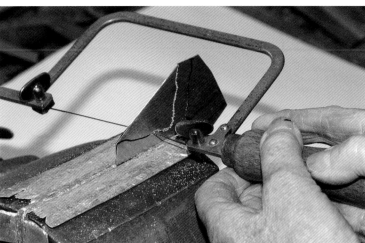

Exercising precise control cutting out a circular blank using the large tin-snips, with one handle fixed in a vice. The extended handle gives greater control.

A piercing saw with a fine blade can cut intricate shapes accurately. It is a frustrating tool to use as the blades break frequently, but there is no better tool for accurate cutting, particularly of sheet metal.

Larger cuts can be made with great precision using the large tin-snips with one handle extended and the other held captive in the jaws of a vice (above). Make sure the cutting edges are kept sharp.

Complex shapes can easily be cut with a piercing saw (top right). This uses a disposable, very thin blade like a fine jigsaw. Hold the piece firmly in a vice and move it around in the vice so that the cutting point is always close to the jaws. Note the aluminium jaw faces. Tube, rod and bar are best cut with a hacksaw.

Once the shape has been cut from the sheet, flatten the copper blank with a mallet or planishing hammer on the steel plate, and file the edges true to the original line (right and bottom right). Check the edges with your fingers to find any unevenness or roughness.

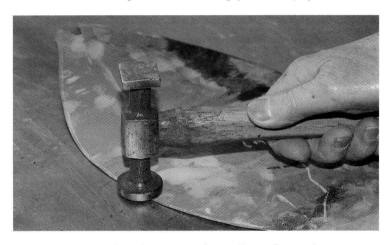

Use a planishing hammer or flat mallet to flatten the blank before truing the edges.

Use a medium-cut and then a fine-cut metal file to file the edges of the blank to the line. In this case, two blanks of equal shape are held together by wooden formers in a vice so that precisely equal blanks are made.

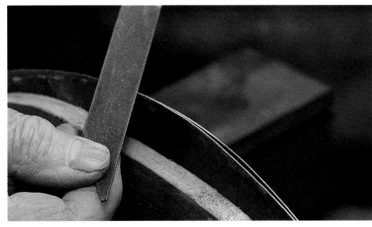

Square mallet (6); planishing hammer (7); small ball pien hammer (8); bossing mallet (9); large hammer (10).

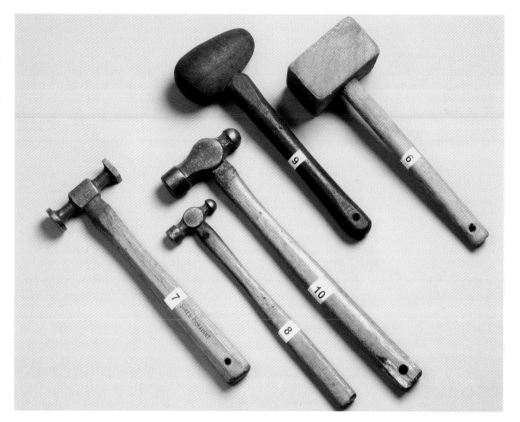

A starter kit of files: fine-cut flat file (13); medium-cut flat file (14); fine-cut half round file (15); a set of needle files (for small intricate work); fine-cut tapered round file (16).

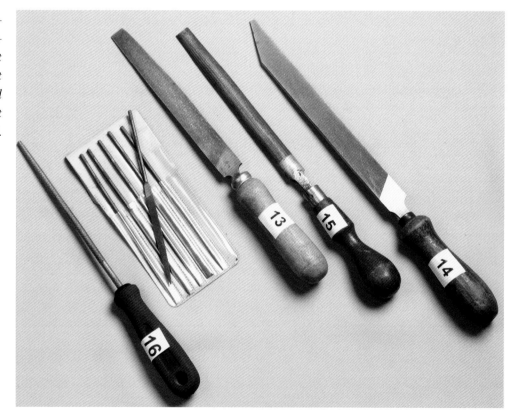

ANNEALING AND QUENCHING

This is one of the critical operations that has to be undertaken in the shaping of copper. The metal becomes hard and brittle when mechanically worked; however, it can be made soft again by heating it in a process known as annealing. When raising a shape like the bowl (described in Chapter 2), the copper blank should be annealed very frequently between sessions of hammering. There is no harm in annealing it too often, but the copper will crack if you anneal it infrequently. The annealing temperature for copper is reached when the metal glows a cherry-red, normally between 370°C and 480°C (698 and 896°F). Copper may be cooled rapidly or slowly, since the cooling rate has no impact on the softening effect of heating it. The atomic structure of copper is lattice-like: hammering tightens the links in the lattice, heating expands and relaxes them. Unlike other metals, copper may be annealed and then worked again and again, *ad infinitum*.

When the correct temperature is reached, the area already annealed is marked by black copper oxide.

The process of heating larger shapes is shown sequentially in the images on the right. It is necessary to heat the entire piece, and to do so in a logical sequence.

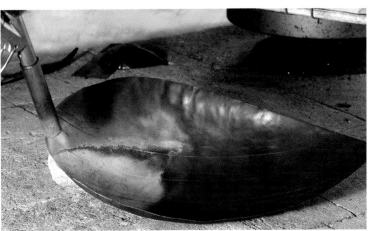

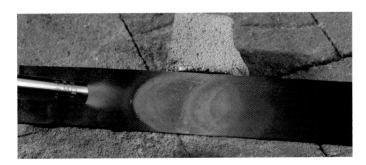

Heating copper to over 300°C (572°F) releases the tight lattice structure of the metal and makes it pliable and easily shaped. In this example, the strip of 0.8-mm copper sheet has been subjected to heat, moving from the right to the left. The area annealed is tarnished with a deposit of black copper oxide, which forms when the copper is heated in air.

When annealing large pieces, you need to work systematically from one end to the other, heating an area of copper to the correct temperature (cherry-red) before moving to the next area. When the entire piece has been treated, it can be quenched.

When the piece is fully annealed, it can be quenched if it is to be handled immediately. Lift it with tongs and plunge it into a bucket of cold water. When it stops steaming, it is cooled and can be removed, then wiped with a cloth to get rid of some of the black copper oxide.

Hot annealed copper can be quickly cooled by dunking it in cold water until it stops steaming. Note the use of tongs to transfer the hot piece into the water. Note also how the water itself removes some of the black copper oxides.

Homemade hammers (from left): a modified carpenter's hammer; two wooden mallets; a hammer made from an old bolt; a texturing hammer made by driving a nail through a wooden handle and smoothing its point. Making your own tools is fun.

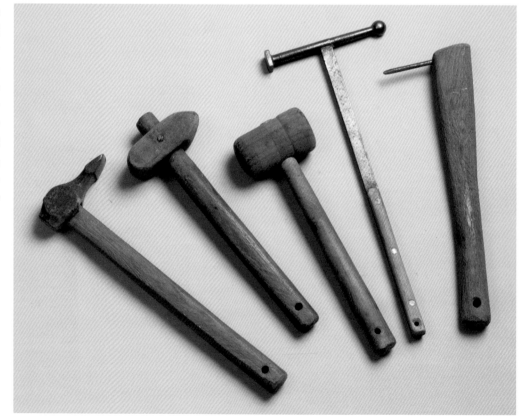

SHAPING (RAISING)

Copper sheet is very malleable and can be worked into complex shapes. A simple shallow dish shape can be made by hammering the blank on a suitable dished block, using a wooden bossing mallet. The copper is beaten from the centre outwards in a spiral. This causes the sheet to crinkle as the pattern of hammering moves outwards, and these folds must be carefully beaten down before they become too large. This stretches and thins the metal, gradually forming a dish shape (see p. 42). Hammering the raised blank against a straight surface (as opposed to within a rounded dish) helps to align and fix the longitudinal shape, which can become deformed during the raising process.

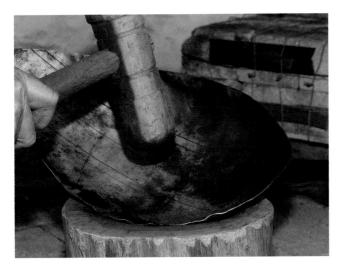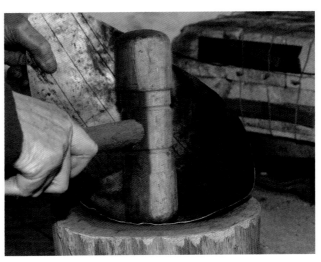

A typical shaping procedure is shown using 0.9-mm copper sheet, beaten in a shallow wooden anvil with a blunt, rounded, wooden mallet. Folds form along the edges, so they are gently beaten from right to left; then the edge is re-formed.

The blank is further beaten, this time on a flat anvil against a straight wedge, so that its longitudinal shape can be formed. (A wedge-shaped strip of wood has been nailed on the top surface of the log, which aids the shaping of relatively flat areas; see p. 64.)

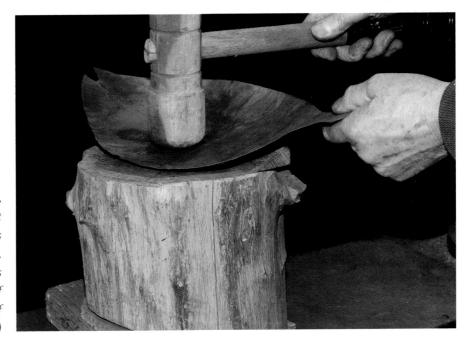

An alternative to a concave anvil for forming dish-shaped pieces, a convex, carved wooden mandrel mounted on a bent bar and held in a vice provides support for pieces that cannot be worked on an anvil. These mandrels provide suitable support for planishing and polishing curved pieces.

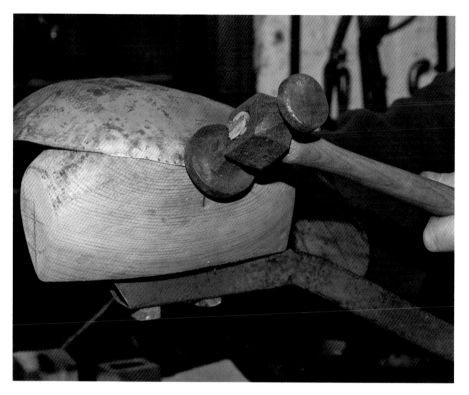

TRUING

Once the desired shape has been created by raising the copper sheet with a wooden bossing mallet, the surface needs to be smoothed. A metal planishing hammer with a large flat polished face is used to gently beat the copper, held over a wood or metal anvil with similar curvature to the piece itself.

The range of shapes needed for Sue's appliqué metal structures is responsible for the bewildering array of anvils she has collected, many of which are as simple as a piece of bent steel pipe (right).

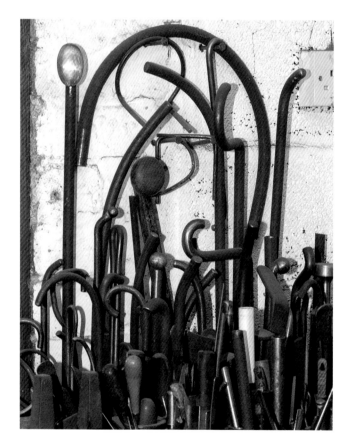

This assemblage of old iron shows some of the pieces used by Sue White-Oakes as anvils over the past 25 years. They were instrumental in making many of her pieces, shown in Chapter 7.

SOLDERING

The process of joining copper pieces relies on the use of high-temperature solder with a melting point above 600°C (1400°F). This form of soldering is also known as silver or hard soldering, the goal being to give a beautiful, structurally sound, but virtually invisible joint. Silbralloy™ solder contains a flux to prevent oxidation of the base and filler materials. Flux is a substance that dissolves away metal oxides and prevents them re-forming when it is heated. Flux also acts as a wetting agent reducing the surface tension of the molten solder and causing it to flow better along the parts to be joined. Tin-lead solder, by comparison, may not incorporate a flux and, although it attaches very well to copper, does not do so to the various oxides of copper that form quickly at soldering temperatures. For this reason, tin-lead solder it is not recommended for use in fine art.

All soldered joints require the same tasks:
* Cleaning the metal parts to be joined.
* Fitting up the joint.
* Heating the parts.
* Applying the filler solder.
* Removing the heat.
* Holding the assembly still until the filler metal has completely solidified.

Depending on the nature of the solder used, it may be necessary to clean the joints after they have cooled. However, Silbralloy™ incorporates flux in the solder rods and matches the colour of the copper well. Another significant advantage with this solder is that the pieces to be joined do not need to be perfectly clean when soldered.

The principle behind soldering is relatively simple. The area to be joined is heated to a temperature where the solder becomes molten. This can be recognised when the copper turns a cherry-red. At this point, the tip of the solder rod is introduced briefly into the flame just above the join and brought into contact with the joint with a dabbing motion. As the solder melts, it migrates along the join. When cool, the solder sticks to each

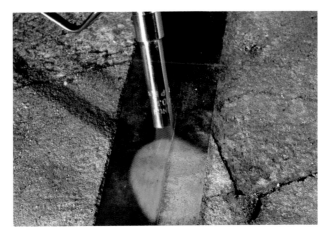

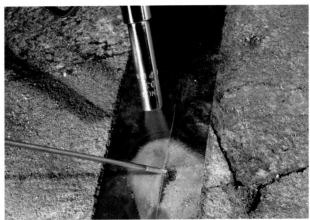

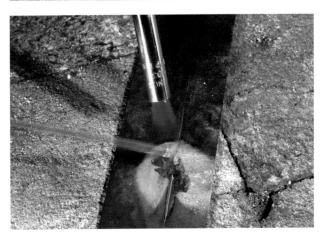

A simple soldered joint is shown here. The two adjacent sheets to be joined are heated to cherry-red (top) and then solder is dabbed into the joint (middle). The solder will migrate by capillary action along the joint. The art is to move the flame steadily along the joint while dabbing in the solder so that it fills the joint (bottom), with as little as possible spreading onto the surrounding metal.

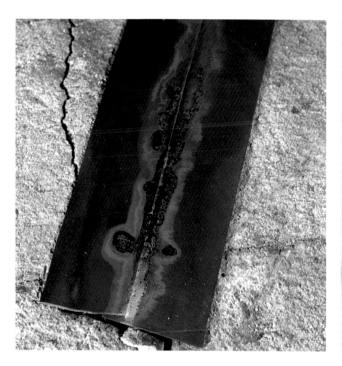

The joint just after completion: the lower end is still red hot. When it cools naturally, or is quenched, the piece will be uniformly black. The solder itself is hardly visible.

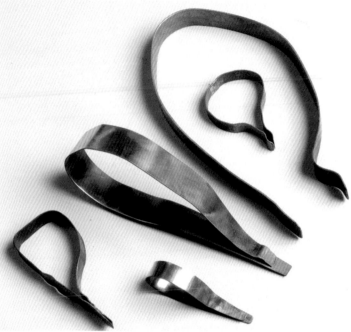

Homemade from strips of tempered steel, these clips are ideal for securing items to be soldered.

surface and so forms the join. However, the join is not a weld *per se* since the surfaces are not fused together: they can be parted by re-heating the solder.

The flux forms a black deposit on either face of the join, which is readily removable with wire brushes.

Soldering copper involves applying high temperatures to a very conductive metal, and there is much to learn about the management of heat in the construction of complex appliqué pieces. Four of the five projects illustrated in this book have their own problems in this respect, and each is dealt with in the relevant chapter. Remember, the objective is to create a long-lasting work of art in which soldering leaves virtually no visible trace.

The shapes that need to be joined together are often complex. Part of the skill in their making is to prepare the surfaces that will be joined with great precision,

and to hold them together without applying excessive force while they are soldered. We show three examples on the opposite page.

In the first example, two sections of a leg need to be joined along their lengths. They are assembled on the welding bench and held together with steel spring clips (depicted above).

There are occasions when it is necessary to shield vulnerable parts of the work from heat. In Example 2, a fine frill, cut from thin copper, is to be fixed to a thicker base, which itself requires more heat than the frill. A simple steel paddle attached to a rod acts like a reflector, keeping the heat from damaging the frill.

Finally, a situation often arises where a third hand would be useful (see Example 3). A simple metal probe that you can hold under your chin to apply pressure to a joint to be soldered offers an often-used solution.

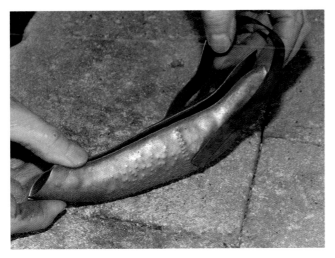

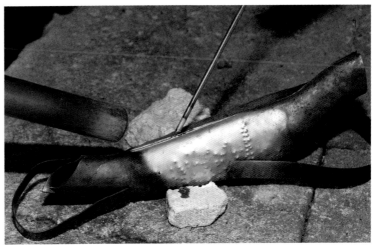

Above and above right: Example 1: Figurative sculpture involves the making of complex shapes, often curvilinear. Welding these shapes together requires some ingenuity, since they have to be held close together for a join to be made. Propping the shape with bits of insulating bricks and cramping them together with steel clips holds them still for soldering. Heat is applied in small areas and drops of molten solder form a tack weld at that spot. While still hot, the seams are squeezed together with pliers. Then the whole length is soldered.

Below left: Example 2: When soldering very delicate copper features onto a larger piece, regulating the heat can be difficult. In some cases, it is necessary to deflect the heat away from a sensitive area. This steel paddle is used for that purpose.

Below right: Example 3: Molten solder penetrates the join by capillary action. It is thus necessary for both surfaces to be touching at the moment when the solder is applied. This steel probe with a wooden button at the top serves as a third hand to press the two pieces together.

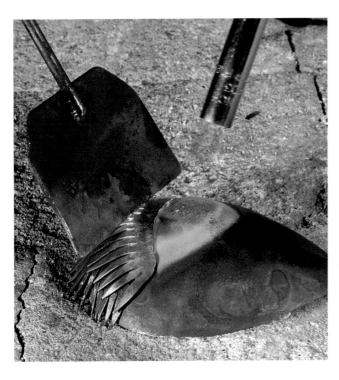

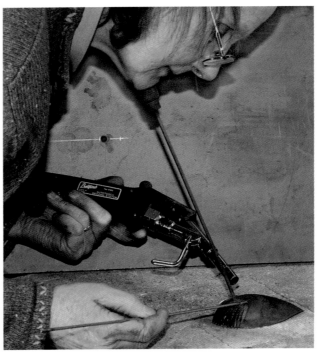

CLEANING

When all soldering is complete, the piece needs to be cleaned before it can be coloured and polished. The oxides of copper that form when heating the metal in air can be chemically or physically removed. Chemical cleaning (pickling) involves plunging the completed piece into a powerful aqueous solution of sulphuric acid (H_2SO_4) to burn off the oxides. Apart from the obvious health and safety hazards of this system, it introduces other problems if the acid is retained in hollow sections of a sculpture after pickling, and it is therefore not recommended in this book.

The mechanical method of cleaning described here uses wire brushes, wire wool and fine emery cloth. The main oxide, cupric oxide (CuO), is an irritant[3] and as the dust that is formed in this process is potentially harmful, it is essential to wear a dust mask and eye protection (see pp. 17–18).

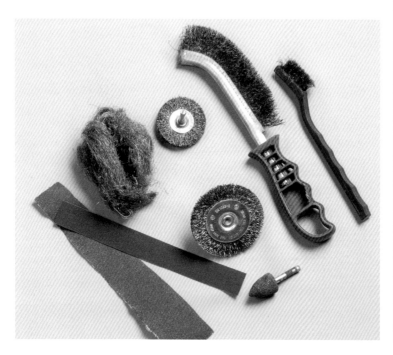

A selection of abrasive tools: emery cloth; wire wool; two rotary wire brushes and a grinding burr (for use in a power drill); two hand wire brushes.

A wire brush fitted into a chuck on the end of a flexible drive provides an effective method for the mechanical removal of copper oxide from a completed structure. Note the use of a dust mask and full-face visor for eye protection.

[3] CAS No 1317-38-0, where CAS = *Chemical Abstracts Service*, a hazard database.

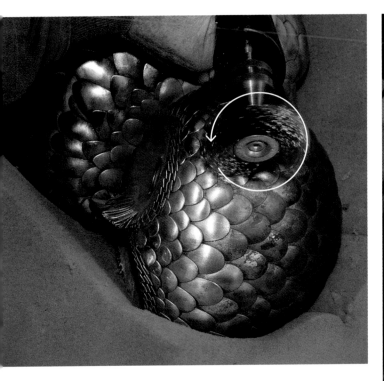

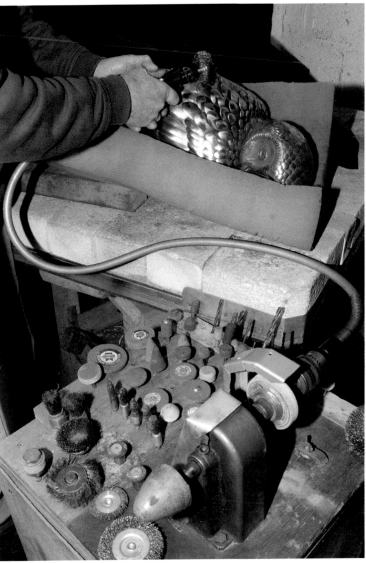

The technique is to brush the surface of the sculpture with the grain, like stroking a cat. Here, the brush is working from left to right (the rotation of the wire brush is anti-clockwise). This operation requires some skill, especially in the choice of the hardness of the brush. The objective is to remove the cupric oxide, leaving the surface smooth and clean for the next process

The homemade stand holds wire brushes and stones in a variety of shapes and sizes, each with a particular function. Many of these may be used on a single piece of sculpture. Wire brushing can, of course, also be done using a power drill to hold the brushes.

Make sure that the brush rotates away from exposed edges.

A rotating wire brush cannot be used to clean in tight corners: this has to be done by hand. In addition to the use of small handheld wire brushes, emery cloth cut into narrow strips and wound around the end of a steel strip can fit into small gaps. Other difficult areas can be cleaned using small grindstones or wire brushes held in a small mechanical grinding tool.

When all of the oxides have been removed, a final clean with wire wool will burnish the piece.

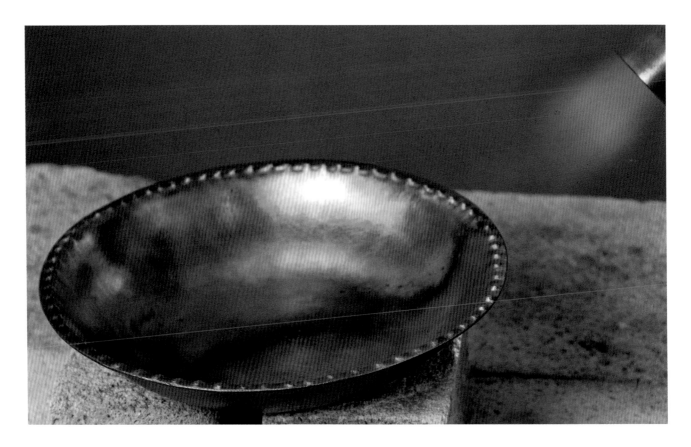

COLOURING AND POLISHING

The cleaned piece is very bright, may not be the desired colour, and will tarnish after a short while. Playing a flame over the piece changes the colour, and may slow down the tarnishing by generating a light covering of copper oxide. This colour change is not fully understood: the wide range of colours that heating produces on copper is clearly related to temperature, but whether the colours represent the stages in the evolution of copper oxides or changes in the refraction of light from the heated surface is not known. Suffice it to say that this is a crucial stage in the completion of a piece, and it requires your artistic judgement to achieve colours appropriate to the nature of the sculpture.

This aspect is covered in greater detail for each of the projects described in the book. Colouring, by the application of heat to the polished copper sculpture, should be practised first on scrap pieces of cleaned

Playing a flame lightly over a freshly-cleaned bowl shows the graduation in the colours, from blue through to a bronze yellow. The art is in stopping at the right moment to get the correct colour, as there is a time lag with the heat.

copper of different thickness rather than on a finished item. However, remember that you can always remove the colours applied and start again. Copper is a forgiving material.

When you have achieved the colour you want on your sculpture it should be wax polished. Use a beeswax colourless, pure turpentine furniture polish and apply it with a small household paintbrush. Once the polish is dry (after about 15 minutes), the piece is burnished manually or mechanically. The application of wax as a polish prevents further oxidation of the surface and maintains the sculpture in the desired colour. Making your own polish is easy (see p. 47).

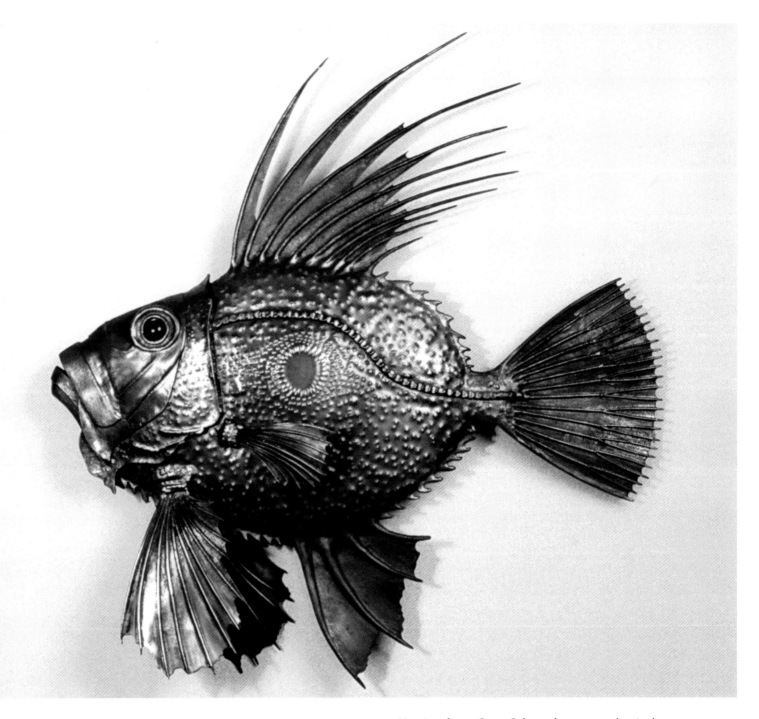

Heating the surface of cleaned copper makes it change colour and become iridescent. The colours are related to the heat applied and the thickness of the copper. Two factors may be involved: one is the production of tiny quantities of oxides of copper; the other is the relaxing of the lattice structure at the surface of the metal, and an accompanying change in refraction of light.

Bowl

INTRODUCTION

This project introduces you to copper and some of its properties in the form of a simple bowl.

The bowl can be as complex as you like. We have chosen a size and style which you should be able to make with a few simple tools in a small space. The emphasis of this project is on accuracy and precision.

The work involves setting out and marking the copper sheet, and cutting and filing it to shape. The bowl is then annealed (softened by heating) and raised by beating. Once the rough shape has been achieved, the geometry of the base is defined and beaten flat and the whole piece planished (smoothed) to provide an even surface. The rim is turned and decorated, and the bowl is finished by colouring and waxing.

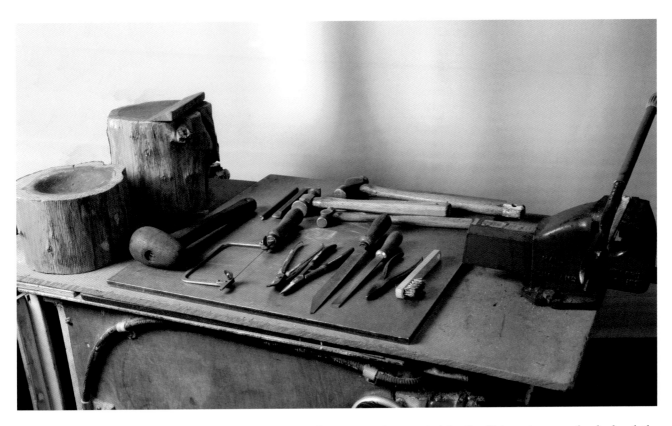

This work bench, approximately 1 x 0.5 m (40 x 20 in.), is of sufficient size to make the bowl, the leaf cluster (Chapter 3), the dragonfly (Chapter 4) and the fish (Chapter 5). Note the engineer's vice bolted on the benchtop and the square, steel plate, invaluable for the truing process.

MARK OUT, CUT AND TRUE

Copper sheet 1–1.2 mm was chosen for this piece, in this case, scrap from a hot water tank.

Mark onto card or stiff paper a circle with the same diameter as that of the final bowl, plus its height. (For example, a 15 cm (6 in.) bowl, 2.5 cm (1 in.) high, requires a circle of copper of an approximate radius 9 cm (3.5 in.) Use this as a template to mark out the copper sheet with a felt-tip pen.

The completed bowl inverted onto the card disc. This demonstrates the extra material required to raise the bowl shape from a flat sheet of copper and form the rim.

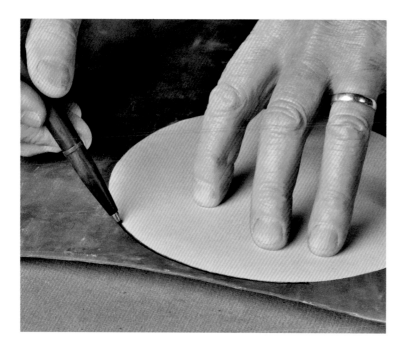

The outline of the copper blank from which the bowl will be formed is marked onto the copper sheet with a felt-tip pen by tracing around the edge of a cardboard disc of the appropriate dimension.

Using the large tin-snips with one handle held in the engineer's vice, cut roughly around the edge of the disc to remove most of the surplus copper and then cut accurately to the line (below left).

This system gives very good control, especially if the snips are kept sharp. It allows very precise pressure to be applied and for the disc to be turned slowly. The more accurate the cut, the less work is required later on.

The edges are trued using first a coarse and then a fine flat file, clamping the disc in the (protected) jaws of the vice. Hold the file at 45 degrees and, with a smooth sweeping action, file around the curvature of the disc (below right). This will remove bumps. Feel the edge with your thumb to find where these bumps are. Sensing smoothness by feel is a good way of detecting unevenness on the surface of metal.

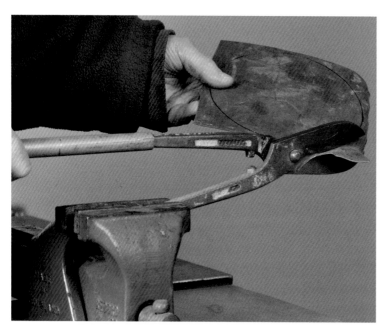

Holding one arm of the shears in the engineer's vice gives greater control when cutting to the line.

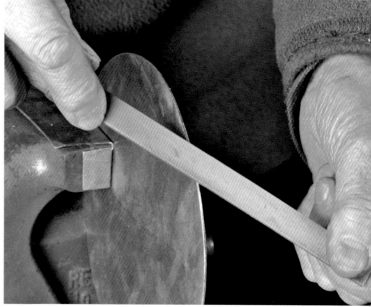

Note that the copper blank is held by aluminium jaws in the vice, and that the file is applied at an angle to the edge of the disc.

ANNEAL

Before any further work can be done, the disc needs to be annealed so that it can be shaped. Heating the copper to above 350°C (662°F) relaxes the lattice structure of the metal and renders it pliable so complex shapes can be formed. Repeated hammering tightens up the lattice again, and further annealing is required frequently. Unlike other metals, copper can be annealed and hammered over and over again.

Learning about the colour changes and what they mean when copper is heated is an integral part of this type of sculpting. At its simplest, you need to heat it until the metal takes on a cherry-red glow. The time it takes to reach this point depends on the thickness of the copper and the temperature of the flame. During heating, the surface becomes blackened with the production of copper oxide. Once the disc has been heated all over to the correct level, it is quenched in cold water.

Once it is annealed, grasp the disc in the tongs (*not* with your fingers) and plunge it into a bucket of cold water. It will cool immediately and some of the black oxide will dissolve. The remainder can be rubbed off with a cloth.

Safety warning: annealing involves naked flames and red-hot metal. Make sure it is done away from combustible materials, electrical cables and power points, children and pets. Keep your feet clear of trip hazards. Make sure you know where the quenching bucket is located and remember that the torch nozzle remains hot after the gas is turned off.

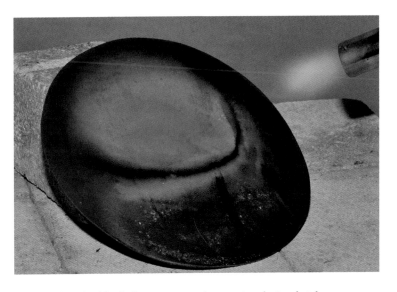

Note that the blank disc is propped up on insulating bricks and is being heated by the gas blow torch. The aim is to heat the entire piece to the colour of the cherry-red area: the rainbow colours indicate lower temperatures. If the area to be heated is large, this can be done progressively. The black deposit around the red is copper oxide.

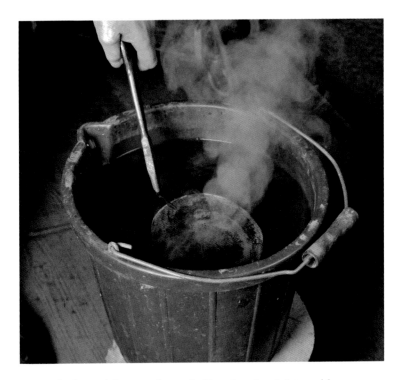

The heated disc can be cooled by plunging it into cold water (as here) or allowed to cool on the bench. Note the use of tongs.

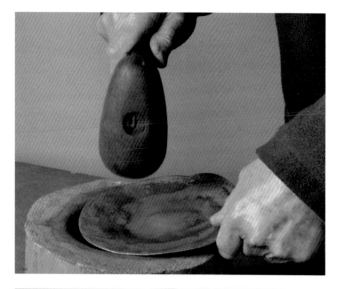

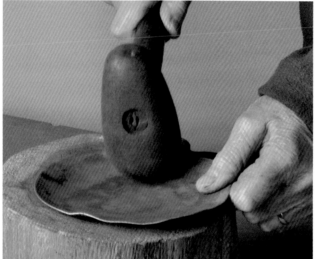

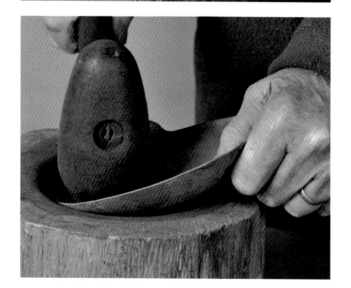

RAISE

The bowl-shape is created by beating the copper disc to stretch the material in a highly controlled manner. The raising process is started on a dished wooden anvil, using a round-headed wooden bossing mallet. Both the anvil and the hammer, shown left, were fabricated by Sue out of scrap firewood and are not difficult to make. As the disc is turned, it is gently beaten from the centre outwards and a shallow dome is formed. This process is fundamental to shaping copper and is used in all the projects described in this book. Obtaining a symmetrical curvature around the bowl with an even thickness takes practice.

The developing bowl was annealed many times before the final shape was achieved. One consequence of raising the bowl from the centre outwards is that folds can occur along the edges due to the unequal stretching of the copper. These folds can be corrected by very gentle hammering around the periphery, redistributing the copper. Continue alternately beating and annealing the bowl until the required depth is attained.

Top: The annealed piece is held over a dished anvil and gently hammered from the centre outwards with a wooden bossing mallet to raise the bowl.

Middle: Folds form along the outer edge.

Bottom: The folds that were evident have been removed by very gentle hammering around the edge, and raising is nearly complete. Note how the depth and shape of the bossing mallet is well suited to the anvil and to the bowl.

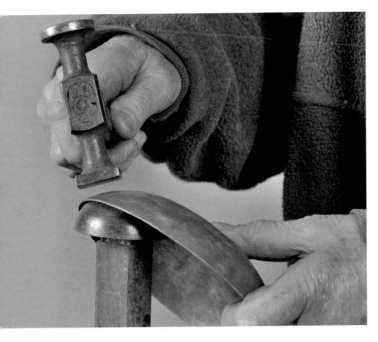

The flat-headed planishing hammer is used to create a smooth, even surface by gentle beating of the bowl held over a mushroom-shaped polished steel anvil.

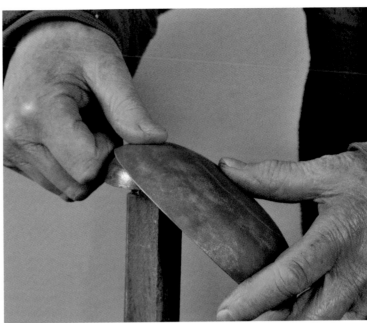

Fingers and thumbs are sensitive and detect flaws in the bowl surface.

Once the final shape has been created by beating on the wooden anvil, the surfaces of the bowl is smoothed with a planishing hammer, a tool with a machined flat face. The bowl is annealed again, cleaned with wire wool, then held over a mushroom-shaped stake in the vice, and gently beaten all over with the planisher (above). The process may need to be repeated several times to remove bumps and blemishes from previous hammering. Remember to anneal the bowl frequently. Throughout this process, run your fingers over the surface of the (cool) copper to feel for uneven patches, the sense of touch being more sensitive than the eye. Distributing the hammer blows evenly takes practice: keep your arms close to your body and use your wrists.

To check for roundness, place the bowl over the circular cardboard template. Minor adjustments can be made by gentle hammering after another annealing.

Use a compass to find the centre of the bowl and mark out the circular base.

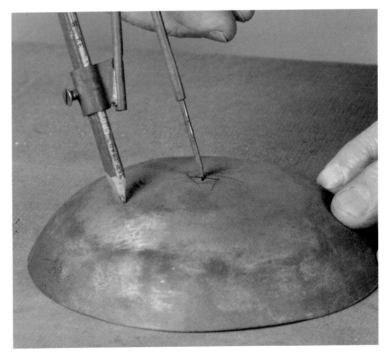

The shape of the foot is marked on the underside once the centre of the bowl has been established using a compass.

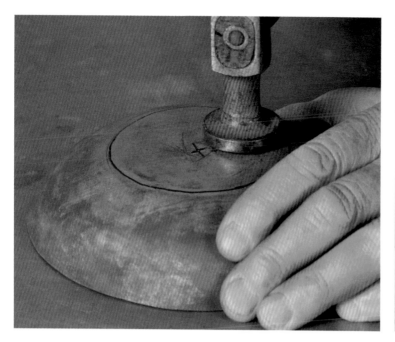

The planishing hammer is used to flatten the base of the bowl into a foot. Accurate blows around the edge of the foot ensure that the edge between the foot and the side of the bowl is clear.

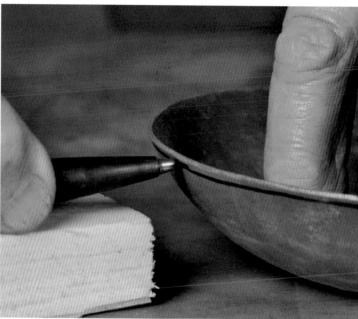

Before the rim is formed, the upper edge of the bowl should be made parallel with the base. The bowl is rotated on its base against a fixed felt-tip pen ...

Place the bowl upside down on the steel plate and hammer the base area flat, using the planishing hammer (above). Turn the bowl over and hammer the inside of the base flat. Repeat this process until the base is true. Giving the base a clean edge on the underside of the bowl makes it easier to delineate the base on the inside.

To form the rim, put the bowl upright on the steel plate and rotate the bowl against a fixed marker to mark an edge parallel to the base (above right).

With curved tin-snips, cut the rim to this line (right). Notice that the curved jaws of the snips are directed away from the disc not inwards as one would imagine.

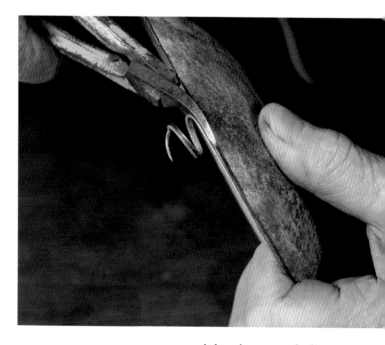

... and the edge cut to the line.

File the edges. Mark a line 8–10 mm (⅓ in.) below the rim on the inside. This is most easily done by holding a felt-tip marker pen between the thumb and forefinger and running the second finger around the rim while rotating the bowl with the other hand (above left).

Turn the rim down by hammering it against a sharp edge (above right). Invert the bowl onto a flat hard surface and, with the planishing hammer, beat the rim flat.

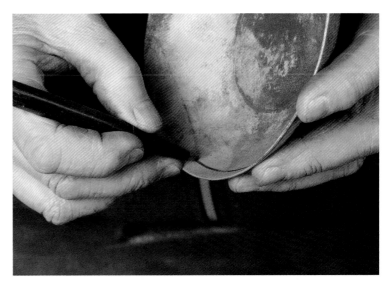

Right, top: Rotate the bowl with a pen held at a convenient distance, to mark the edge of the rim.

Right middle: Hammer the edge of the bowl against a sharp edge to form the rim.

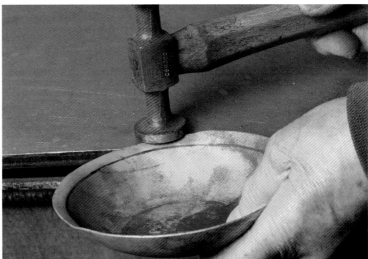

DECORATE

The next part of the work is called *repoussé* – shaping a decorative motif from the inside by marking or *chasing* with a punch. In this case, the decoration is a simple row of raised spots made with a round-headed punch, previously marked with a pen around the underside of the rim.

Note that the rim is supported on an end-grain of a clean softwood block, which provides a firm but resilient base for hammering. The position of each repoussé raised spot has been marked on the underside of the rim.

COLOUR AND POLISH

Repeated annealing of the piece during its making discolours the copper. Before the work can be given its colour of choice, it is necessary to take it back to its base copper colour by wire brushing and rubbing it with fine wire wool.

Playing a flame over cleaned copper changes the lattice structure of the copper atoms, and alters the refraction of the light reflected from the surface. Heating copper in air also oxidises the surface. These two characteristics of the metal allow the artist to alter its colour (as we will see with the fish in Chapter 4), which makes a significant contribution to the final look of the piece. We suggest that the first-timer practises on spare off-cuts of copper to learn how to control the process using their own gas torch.

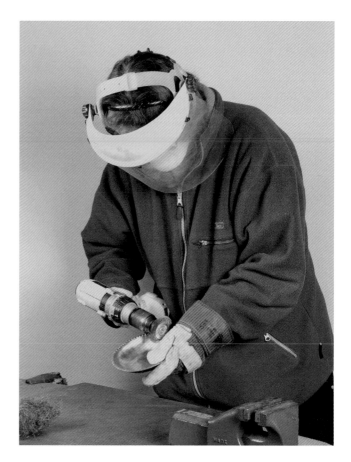

Note the gloves, face mask and eye protection for this part of the work. Use coarse wire wool and wire brush for the first part of this process.

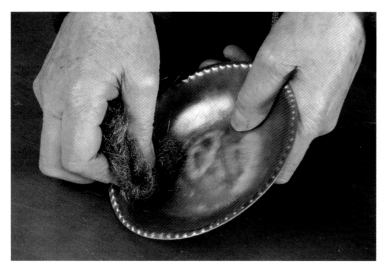

All traces of copper oxide are removed with fine wire wool before colouring.

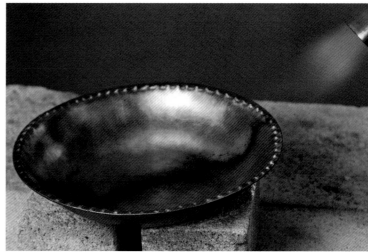

Playing a flame lightly over the surface of the cleaned bowl changes the surface appearance of the piece.

Finish the bowl by polishing with a beeswax and turpentine polish. This will seal and protect the surface. This polish (often used for furniture) can be bought in any good hardware store, or made by dissolving beeswax into pure turpentine to make a soft paste. Do not use white spirit or turpentine substitute, as these will not work.

Leaf cluster

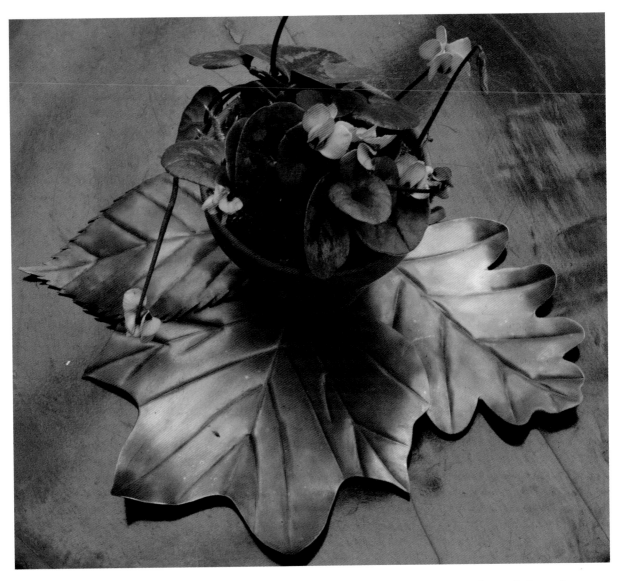

This project is designed to show you how to create interesting and varied shapes in copper sheet, and to fit them together. The result is an attractive and useful table decoration.

INTRODUCTION

This project extends the skills learned in Chapter 2 by including soldering, which is the means by which pieces of copper are joined together. The project is to make a decorative cluster of leaves that can be used, for example, as a table centrepiece or the base for flower arrangements.

The work involves creating a strong design, accurate cutting of curves, surface decoration, shaping, soldering, colouring and polishing. Copper sheet (0.7–0.8 mm) is used throughout.

We will also describe how to make simple hidden solder joints. In the succeeding chapters, we will consider how to make visible joints and how to manage heat in larger works. Soldering equipment has already been described in detail in Chapter 1. The tools required are those used for the making of the bowl (Chapter 2) and the dragonfly (Chapter 4).

MARK, CUT AND ANNEAL

The artistic expression in this piece is in the choice and arrangement of the leaves. Gather fallen leaves locally, trace their outlines onto thick paper and cut these out to form templates.

Small leaves can be enlarged by photocopying or through photography, to provide a balanced set. The templates are arranged to check that they work as a group. The outline of each leaf is traced onto thin copper.

Cut out the shapes using curved and straight tin-snips.

File the edges (with a fine file) and anneal. Remember, the copper sheet in this project is thinner than that recommended for the bowl (Chapter 2) and requires less heat input.

The patterns are carefully prepared from fallen leaves, increased or reduced in size to suit the arrangement. Note the attention to detail in marking the veins and the perimeter, and then the care with which the card is cut.

Trace around the card patterns onto 1.2 mm thick copper sheet. Carefully cut out using curved or straight tin-snips. The edges are filed and the copper blanks annealed before they are beaten flat with the planishing hammer.

Curved tin-snips are designed to cut intricate shapes.

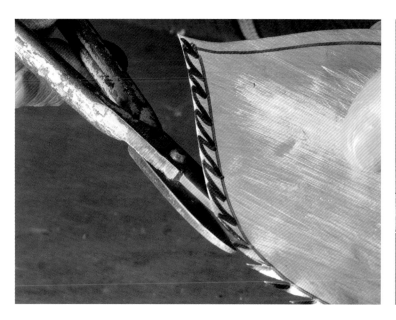

Straight tin-snips can cut both straight and curved shapes.

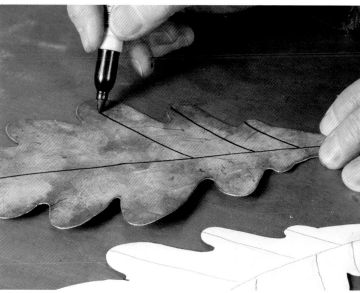

The veins on the leaves are important structural and decorative elements, and are carefully marked before they are chased on to the copper blanks.

DECORATE AND SHAPE

Reproducing the natural veins of the leaves will give the project credibility, and the original leaves should be kept for this purpose. Draw the veins on the copper cut-outs with care.

Before attempting to chase the veins onto the sculpture, try out the technique on annealed scrap copper. Place the copper onto the end-grain of a wooden block. Using your modified brick chisel (p. 23), and starting at the leaf stem, work towards the tip holding the chisel so that the leading edge runs easily on the surface and does not dig into the copper. Make light taps with the hammer on the first run, and then go over the same vein again until you have a smooth indentation of even depth and width. Repeat the process for each lateral vein, starting from the point where they join the centre vein and working outwards. Often, the veins become thinner towards the edge, and this is a refinement you should be attempting to reproduce. Once you have mastered the technique, shown on the opposite page, work on the sculpture.

When all the veins are complete, anneal the leaves. You are then ready to create their surface shapes. However, remember not to handle red-hot copper: use tongs to quench the pieces after heating them. Shape the leaves using the bossing mallet on a wooden block (see p. 52). This block can be hollowed (see p. 42) or have a simple straight wedge to provide the concavity of the leaves.

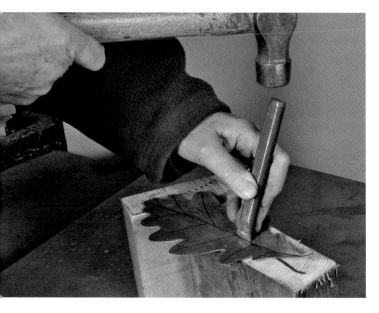

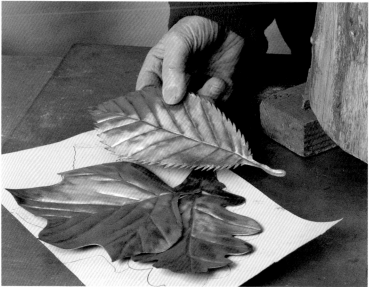

The main vein is chased starting from the bottom of the leaf and working towards the tip, its width (which decreases towards the tip) being managed by the strength of the hammer blow applied. The shape of the bevel on the brick chisel will affect the width and depth of the chased vein, and may have to be modified. Note that the copper blank is held on a piece of clean, square-cut end-grained softwood, and that the cutting head of the brick chisel is slanted away from the direction of travel to prevent it from cutting the copper.

This is a three-dimensional piece of sculpture, albeit mostly within a single plane. When they die and dry out, leaves twist and curl and this element needs to be brought out in an assemblage where leaves lie on other leaves. Before embarking on the next step (which is to give the leaves shape), the arrangement should be decided and drawn on card. The position of the lower leaf will determine that of the upper leaves.

The importance of carefully crafted veins to the credibility of the piece is obvious here.

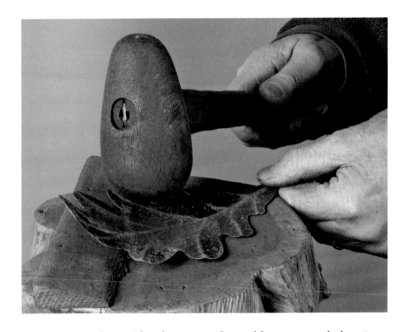

You can twist, curl or bend the leaves as you wish – remember that they will need to fit together. You might care to shape them to hold a receptacle. The hammering required is surprisingly gentle.

Arranging the leaves into a satisfying group is the artistic part of this project. Before fixing the leaves together, they need to be cleaned using wire brushes or wire wool. Whichever you decide to use, always brush from the centre outwards towards the edges, like stroking a cat. Wear protective clothing (face mask, eye protection and gloves) as necessary.

Above: The shapes are formed by very gentle beating with the rounded wooden bossing mallet on a wooden anvil fitted with a simple linear wedge. Compare this to the shaping of the bowl (Chapter 2), in which a dished anvil was used.

Below: Before they are soldered into a single object, the final layout (and thus the shapes of the three leaves) is decided. This is then carefully lifted, keeping the leaves in their relative positions, and turned over onto insulating bricks for soldering.

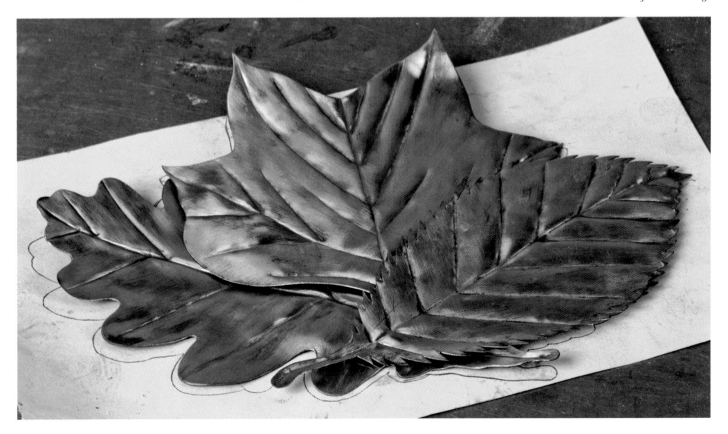

SOLDER

The leaves are soldered together from below, so that the soldered joints won't show. Hold the group of leaves tightly in their final arrangement.

Turn the arrangement onto its back on the welding bench. Direct the heat from a flame onto the places where the leaves touch until they turn cherry-red, then dab on a small amount of solder (below).

Keeping the heat on, press the leaves together with any fine, long-handled tool. Keep the pressure on for a few seconds while removing the heat. Turn the piece over when it is cool and check that no solder has run on to the upper surface. Techniques for removing unwanted blobs of solder are described in Chapter 5, p. 83.

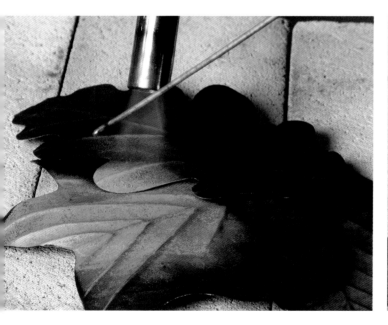

The first soldering point is where the lower and middle leaves touch each other. The copper in this area is heated to a cherry-red, the solder rod introduced into the flame above the soldering point, and a drop released into the join where it migrates by capillary action into the space between the two blanks. This is the first of about six spots where solder is applied to create a firm piece of sculpture.

The drop of solder shows as a silver spot on the cooling copper. Note how heating the copper to a high enough temperature for the solder to melt has resulted in the widespread formation of black copper oxide, which has to be removed later.

CLEAN, COLOUR AND POLISH

Before the piece can be coloured, it is necessary to clean it thoroughly. This involves taking it back to bare metal using a wire brush and wire wool (the same process described in Chapter 2, p. 46). The rule is to brush from the centre outwards towards the edges, particularly when using a drill-mounted brush, as shown right. Finish off with wire wool.

This next part of the work provides scope for imaginative treatment of the piece, using colour to express the objectives of its maker. In nature, one of the interesting features of leaves in the autumn is the vast range of colours and textures displayed. Heating copper changes its surface structure and, hence, its refraction and reflection of light. The addition of a thin layer of wax gives the piece a subtle, lustrous finish.

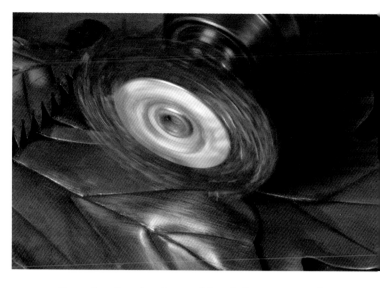

Once the piece has been soldered, the copper oxide deposit is removed, initially with a wire brush. In this case it rotates within an electric drill.

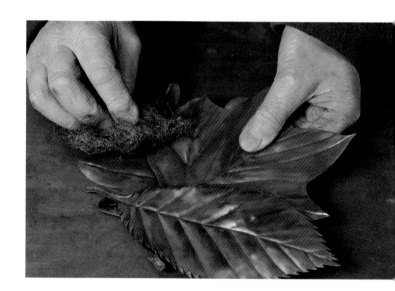

Wire wool is used to complete the cleaning process and to remove the coarse scratches left by the drill-mounted wire brush.

There is no precise recipe: it is up to you to practise using off-cuts with your own heat source to find out how to achieve the colours that you want to use. However, one word of warning: remember that the copper gets hot, and we would recommend you wear welding gloves when doing this. Once colouring is complete, polish the piece with beeswax and turpentine polish (as described in Chapter 2, p. 47).

Both the bowl and the leaf cluster have introduced you to simple, basic techniques for using copper imaginatively. In both examples, the need for precision is clear.

Playing a flame lightly over the surface brings out a host of colours in the copper. However, take care not to overheat the work and cause black copper oxide to form or (even worse) the welds to melt.

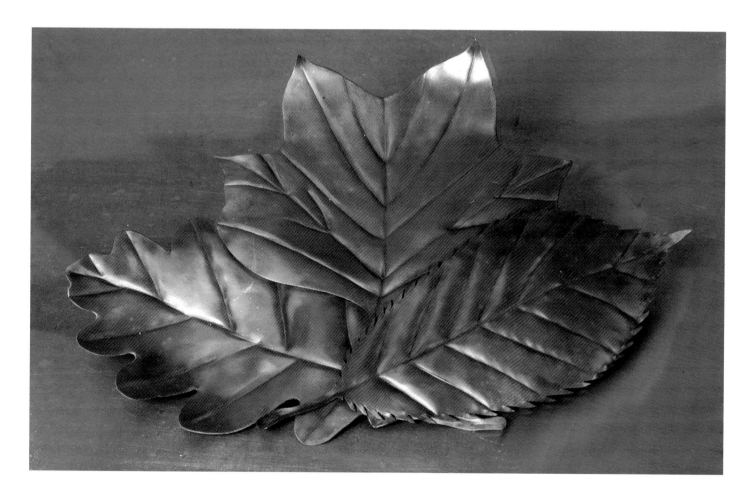

Dragonfly

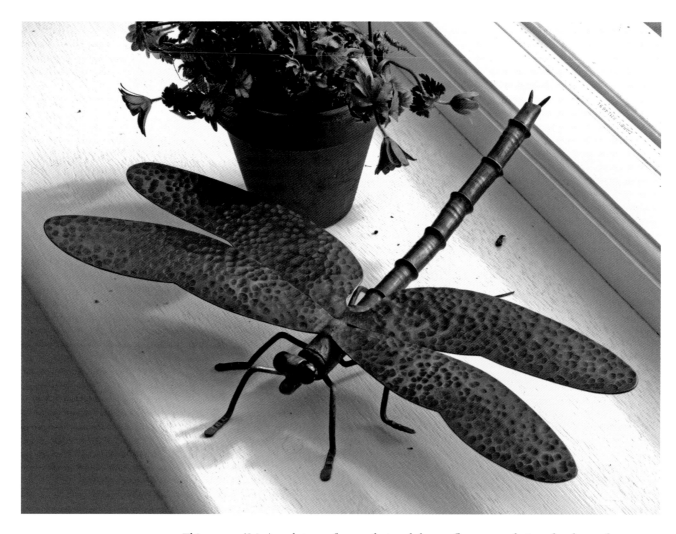

This 20-cm (8-in.) sculpture of an archetypal dragonfly was made in a few hours from scrap copper tube and sheet. It utilises some basic copper-handling skills, many of which are used every day by plumbers. The method of construction is straightforward and broken down into several simple steps.

INTRODUCTION

The leaf cluster project introduced you to the process of soldering for the creation of a small piece of sculpture which, though free-standing, does not depend on a specific point of balance to succeed. In this project, balance and stance are all important. We have chosen a simple robust insect.

Each species of insect is highly specialised, as is evident from its shape and size. In general, insect bodies are arranged in three parts:
- *Head*: containing eyes and mouthparts.
- *Thorax*: semi-rigid structure where the legs and wings are attached.
- *Abdomen*: soft, segmented flexible organ involved in digestion and reproduction.

The head is at the front, the abdomen at the rear, with the thorax in between. These three parts are clearly separated in the adult dragonfly.

The head is that of a predator, with huge eyes and a large mouth. The abdomen is segmented and typically curved upwards at the tail end. The two pairs of wings articulate on top of the thorax and, at rest, are outstretched, prominent and flat. All six legs grow from the underside of the thorax. Dragonflies are brilliantly coloured and in sunshine they scintillate and flash as they dart over water. Of all metals, copper is supreme in its ability to catch these fleeting sparkles.

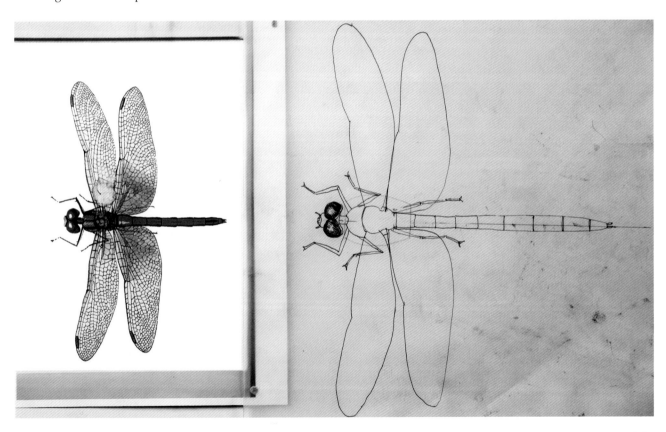

A full-size plan drawing based on a book illustration. It shows the main features of the sculpture and is referred to frequently.

PLAN

Scale-up an illustration from a book to a suitable size: in this case, a body length of 20 cm (7¾ in.) with wings 25 cm (10 in.). The skeleton is 6-mm diameter copper tube on to which 25 mm (1 in.) segments of 10-mm diameter tube are soldered. The wings are 0.8-mm sheet, the thorax 15-mm pipe and the legs 2.5-mm wire. The eyes are 10-mm beads, set in the head, which is 10-mm pipe. The same tools used for making the leaf cluster (Chapter 3) are required.

BODY

Cut a piece of 6-mm pipe measuring the length of the dragonfly's body and head, plus about 4 cm (1½ in.). Bend it to the final shape of the abdomen, which is typically raised at the end. This pipe is the skeleton of the piece on to which all the other components are fitted.

For making the abdomen segments, hold a 25 cm (10 in.) length of 10-mm pipe in a vice, with about 1 cm (⅓ in.) protruding at one end. To swage one end of each segment, use a piece of 6-mm-diameter steel rod about 30 cm (12 in.) long with rounded ends.

One end of each segment is widened by swaging (belling it out), in this case by rotating a rounded steel rod held at an angle to the copper pipe, which is held securely in a vice. The swaged end of the pipe is cut with a hacksaw. Note that the cut is made close to the vice.

Below: The body is constructed of one thoracic section (3.5 cm, or 1½ in.), six abdominal sections (2.5 cm, or 1 in.) and one tail (2 cm, or ¾ in.) in segments of 10-mm pipe, each fitting into the swaged end of its neighbour. The segments are strung onto 6-mm copper pipe, bent in a gentle curve to mimic the stance of this rapacious fly.

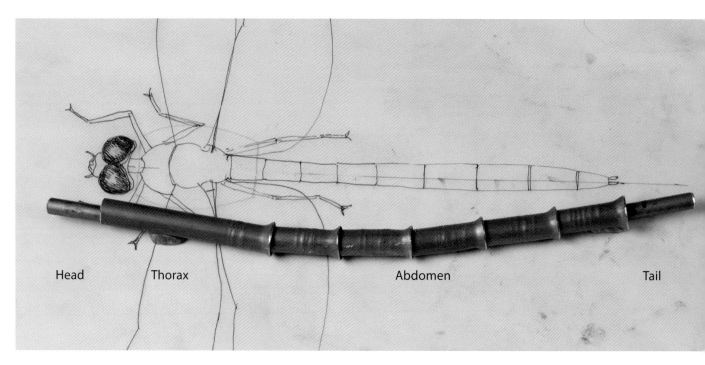

Head Thorax Abdomen Tail

Insert it a few millimetres into the end of the copper pipe, and rotate it to bell out the end of the tube (as shown left).

The aim is to produce a flange wide enough to accept the diameter of the pipe being used, so that the segments of the abdomen will fit snuggly together. Check the swaging is wide enough with an off-cut of pipe and, when it is of suitable size, cut a 2.5 cm (1 in.) length and file both ends. Repeat the same process until five segments have been made for the abdomen. Remember to cut one extra-long (5.5 cm, or 2 in.) segment for the thorax (see drawing opposite). This will have another tube of larger diameter threaded over it to make up the thorax and hold the legs. Assemble all of the segments onto the 6-mm pipe and check them against the drawing.

Once you are satisfied that each segment is of an appropriate standard and they fit together, suspend the 6-mm pipe between two kiln bricks, with all the segments assembled on it (shown top right). Check they are evenly aligned. Heat each segment in turn until it is a cherry-red. Introduce a small amount of solder into each joint. The solder should not be readily visible, so that the segment ends stand proud of each other.

For the thorax, cut a 3.5 cm (1½ in.) length of 15-mm pipe and file the ends smooth. As this will be a loose fit over the thorax segment, the ends need to be turned inwards to reduce their internal diameter to 1 cm (½ in.). To achieve this, place a steel rod horizontally in the vice with about 2 cm (¾ in.) protruding. Anneal and cool the 15-mm pipe. Place one end over the rod and hammer at an angle on the end, continuously rotating the tube until it fits snugly over the first long body segment. Do the same for the other end, again reducing it to fit snugly on to the long body segment. This will form the thorax. File the ends to smooth them off, place it into position and heat it to a cherry-red. Then solder it in position over the front of one thorax tube.

The assemblage is suspended on insulating bricks before soldering.

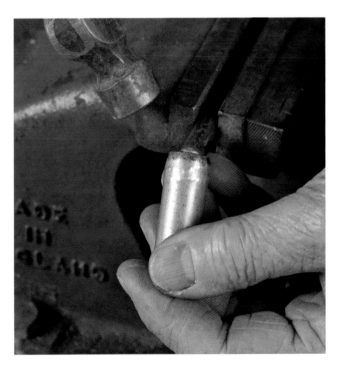

The thorax is made of 15-mm pipe, with ends tapered down to 10 mm (⅓ in.) to link into the abdomen. The length of pipe is annealed and cooled, and held over a steel rod and rotated with one hand while being gently hammered with the other. When both ends have been tapered, this thoracic segment is filed and then soldered over the 10-mm thorax pipe. (The tapered ends are clearly shown.)

LEGS

Holes for the legs are marked on the underside of the thorax, centre-punched and carefully drilled (below).

Note that the front and middle legs are relatively close together. The legs, which are bent out of 2.5-mm copper wire, will fit into the six holes drilled in the thorax. Choose three bends to represent the three joints on each leg, the lengths of each leg 'bone' being roughly as follows:

Leg bone	1	2	3	4
Front leg	10 mm	18 mm	25 mm	19 mm
Middle leg	10 mm	18 mm	25 mm	19 mm
Back leg	10 mm	26 mm	25 mm	19 mm

Draw the legs on paper and cut the wire to the appropriate lengths (below left), allowing a little extra. Anneal the wire and bend it into shape using pliers. Flatten and anneal the feet and give them some texture with a punch made from a piece of steel rod (below right). *Do not fit the legs yet* – they will be fitted after the wings.

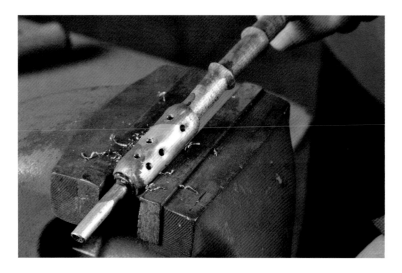

The insect has six legs, three on each side of the thorax. Their position is marked on the underside of the thorax, centre-punched and drilled with a 2.5-mm drill. Note the tapered ends of the thorax.

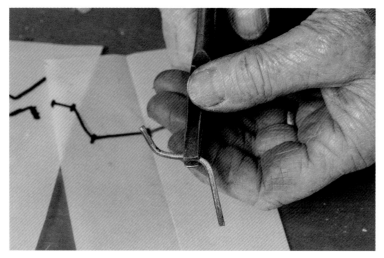

The shape of the legs is a matter of choice. To be credible, they need to support the body in a stance that gives it stability. Sue White-Oakes chose three joints per leg, drew each pair to scale on paper and then bent 2.5-mm copper wire into these shapes.

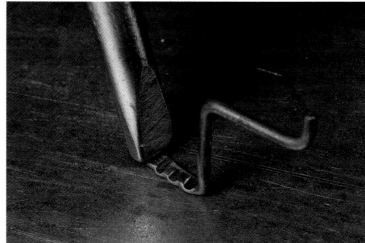

The bottom section of each leg was textured using a punch made from a steel rod.

TAIL

For the tail, cut a short (2 cm, or ¾ in.) length of 10-mm copper tube. With the straight tin-snips, cut a triangular sector from the tube so that it can be hammered into a taper.

Anneal and straighten the taper with round-nosed pliers, then hammer it on an armature held in the vice into the desired shape, which is round at the end to join with the body segments and slightly flattened at the narrow end, where the claspers fit into a narrow slot.

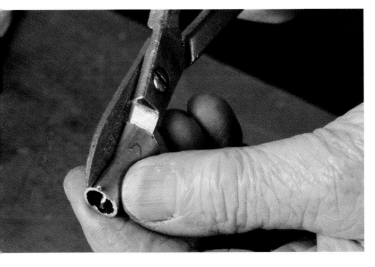

The last tail segment is tapered along its length to hold the twin claspers. The pipe is split along its length with straight tin-snips.

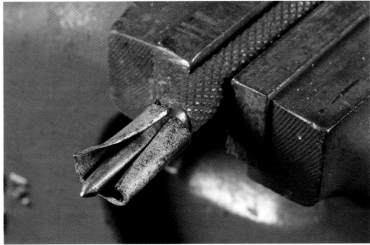

A second cut at an angle to the first removes a wedge of copper so that the taper can be formed by bringing the two edges together around a tapered armature, in this case a centre-punch held in the vice.

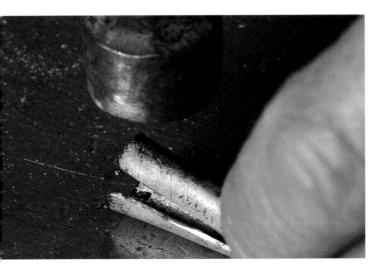

Once the taper is formed on the armature, the edges are brought together with a hammer.

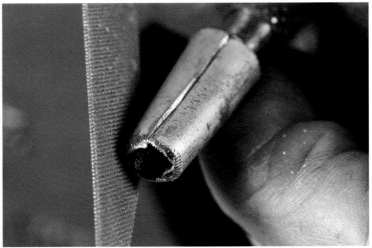

The completed segment is held on the armature and filed true before it is soldered.

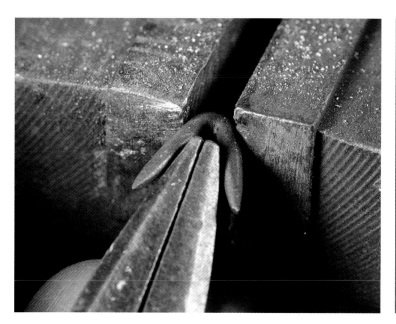

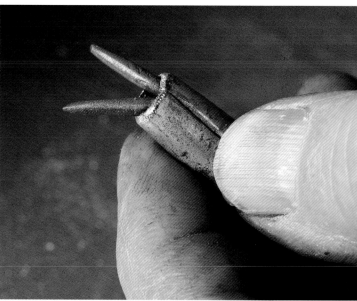

The length of copper wire is annealed and the ends filed into points. It is then bent with pliers and squeezed in a vice into a tight 'V' shape. Put the jaws of the pliers between the points as they are squeezed to keep them apart.

The pair of claspers is fitted into the small end of the tapered segment, which is slightly flattened to accommodate them. They are soldered into position, as is the junction between the two sides

The claspers are two small pointed structures made from a length of 2.5-mm copper wire 4 cm (1½ in.) long, the ends of which are filed into points. After annealing, the wire is bent, fitted into the slot in the tail segment (above right), and soldered into position.

Cut away any surplus 6-mm tube from the tail end of the abdomen. The complete tail assembly can then be soldered into position onto the last body segment (right).

Warning: take care not to direct too much heat on to the other segments in case their solder melts.

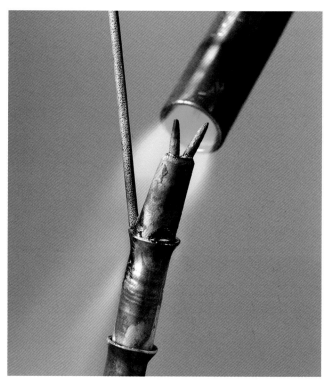

The tail assembly is fitted into the swaged end of the last (abdominal) segment.

WINGS

Cut out the two pairs of wings from 0.8-mm sheet and flatten them by hammering. File the edges smooth, taking care to get the shape accurate as the wings are the defining part of a dragonfly. Anneal them and add texture by hammering with a ball pein hammer.

The wing will curl as you hammer, so turn it over, anneal to soften it, then hammer it flat again with the planishing hammer.

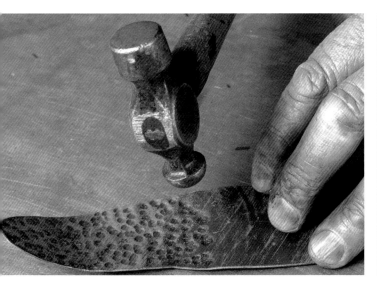

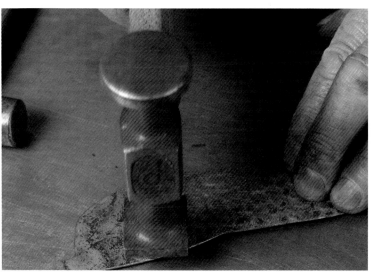

It is not possible to reproduce the delicate and precise venation of the wings. A suitable compromise is texturing and decorating the wings by raising spots using a ball pein hammer on an annealed and cooled wing, held on a sheet metal plate. This is repoussé work.

Hammering the texture inevitably deforms the shape of the wing, which is straightened and flattened with the planishing hammer on the steel plate.

After texturing, the wings are annealed by heating each to an even cherry-red. The black deposit is copper oxide. Some of the oxide is removed by quenching, the rest by rubbing with wire wool.

Clean the wing with wire wool and re-file the edges where they are uneven. To add strength and shape to the wings, give them slight curvature by hammering them from the underside using the bossing mallet (or homemade mallet, as shown right) and the wooden block.

When you are happy that the body is finished, fix the wings. Hold the body horizontally on the welding bench using pieces of brick (below left). Place the wings in position, using bits of brick to support and steady them. Heat the body with the flame pointing away from the thorax until the area of the wing roots is glowing evenly, and then run the solder into the joints. This all has to be done swiftly to avoid heat transfer to the rest of the body. The management of heat will be considered in more detail in the next project (the fish), in Chapter 5. Make a thorough inspection of your dragonfly at this point.

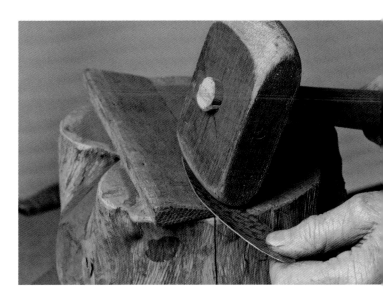

The textured, annealed and cleaned wings are given extra rigidity by gently doming them along their lengths. This is done by hammering a curve with the bossing mallet along the underside using a straight wedge fixed to a wooden block (see also p. 29).

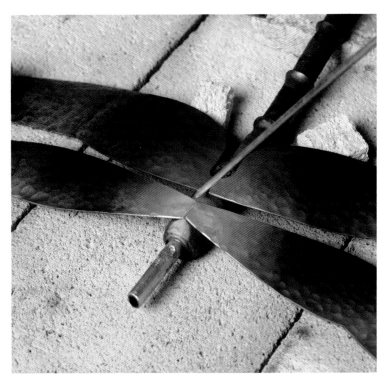

The wings and body are held securely in position by pieces of insulating brick and soldered on to the top of the thorax.

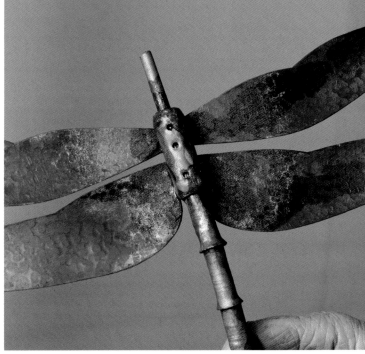

With the wings in position, the piece is examined for imperfections, including unwanted solder, which is removed before the legs are attached.

FIX LEGS

Turn the sculpture onto its back, place it on the welding bench and weigh it down with pieces of brick. Place all the legs in their holes in the thorax and support them on pieces of brick. This is tricky and it is useful to use small clips to hold the wire legs or cut small grooves in the bricks for the leg wires to slot into. Solder the legs into position keeping the torch horizontal to avoid heating the wing joints on the other side of the thorax. When the legs have cooled, use pliers to bend them until the creature stands well.

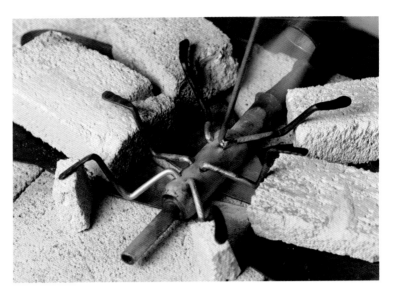

Legs are pushed into their holes in the thorax and supported on bits of insulating bricks.

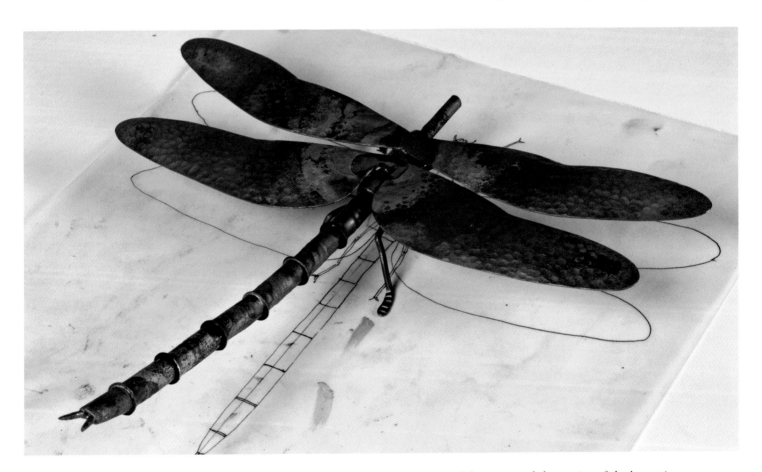

The stability of the piece and the setting of the legs, wings and body are checked before the head and eyes are fitted.

HEAD

The head consists of a short length (5 mm, or ¼ in.) of 10-mm pipe set crossways on to the skeleton pipe at the front of the thorax (below).

The ends of the head pipe are filed flat, and the inner edge tapered to accept the round beads that will be the eyes. The head is soldered into a groove, made with a round file on the top of the skeleton. It is a useful trick to place a small metal weight on the head to hold it steady under the flame (below right).

When it has been soldered, cut off most of the protruding skeleton tube leaving a short length to mimic the mouthparts. Flatten this stump by placing it over the edge of the steel plate or a vice jaw and hammering it from below. File to an appropriate shape. The eyes are not fitted until the rest of the sculpture has been completely finished.

CLEAN AND COLOUR

Use wire wool and wire brushes to remove the surface oxides that have formed during the various heating processes, remembering to brush outwards. Attention to detail is now important, and fine emery cloth may be needed for parts that are difficult to brush.

The sculpture should now be a clean, bright copper.

Stand the sculpture on the welding bricks and play a large flame over it once, from head to tail. Allow it to cool, observing what colours emerge. This is a matter of experiment and experience. Generally, the thinner metal of the wings will colour up long before the body, which requires more heat to bring out the colours. Remember, if you get it wrong and it all goes too dark, you can clean it with wire wool and try again.

Copper lends itself to producing those flamboyant, iridescent colours that are a feature of dragonflies and damselflies.

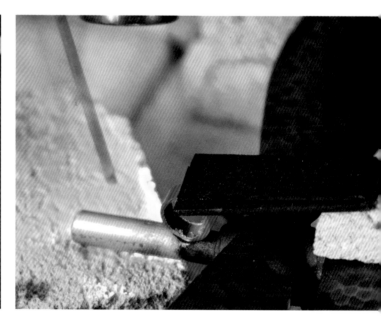

The head consists of a length of copper pipe set crossways in a semi-circular groove filed on the front segment.

The head is held in position for soldering by an off-cut of steel.

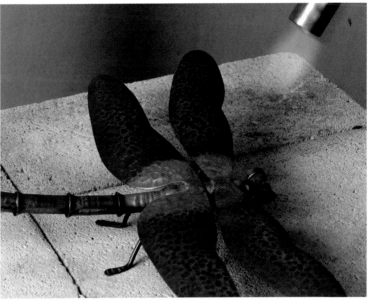

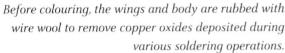

Before colouring, the wings and body are rubbed with wire wool to remove copper oxides deposited during various soldering operations.

Dragonflies are known by their iridescence and bold colours, which change with the angle of sunlight. Copper is an ideal medium for catching and reproducing these fleeting colours, by playing a flame gently but quickly over the cleaned surface.

The sheen on the wings after colouring is evident. Note that the eyes are yet to be fixed.

FIX EYES AND POLISH

Before polishing, the final act is to fix the eyes into the head. You will need a matching pair of pre-drilled beads. Choose a piece of fine but stiff wire that threads through the beads. Glue one end of the wire into a bead with epoxy resin (Araldite) and allow it to dry. Cut the wire to the right length to connect through the head tube and align the second eye on the other side of the head, without showing any wire beyond either bead. When the wire has been trimmed to the correct length, thread it through the head and glue the other bead into position. The aim is to attach the eyes without showing any glue or wire.

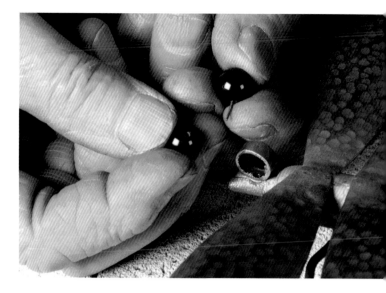

Use a pair of ready-drilled beads for the eyes, in this case 10-mm black onyx.

Coat the whole piece with a beeswax and turpentine polish, applied relatively sparingly with a paintbrush and polished after 15 minutes. This polish prevents unsightly oxidation of the surface and preserves the colour of the piece.

We hope that if you embark on this, or any of the pieces featured in Chapters 2 and 3, it will give you a taste for working with this most forgiving of metals, and furnish you with some basic skills to tackle something more complex, such as the fish in the next chapter. Just as important, if this is your first brush at close quarters with a member of the insect family, we hope that it has whetted your imagination and desire to know more about these fascinating creatures.

This small free-standing sculpture has introduced you to a number of techniques that you might find of use in the future.

Fish

INTRODUCTION

In Chapter 3, we showed you how to join plates of copper together. In Chapter 4, these techniques are used to create a free-standing sculpture of a dragonfly. The dragonfly was made from copper pipe and wire, and was relatively straightforward and forgiving to solder.

In this chapter, we take these techniques a step further and show you how to make a sculpture where careful management of heat in the soldering process is allied to precision in the cutting and joining of two elliptical panels that form the hollow body of a fish.

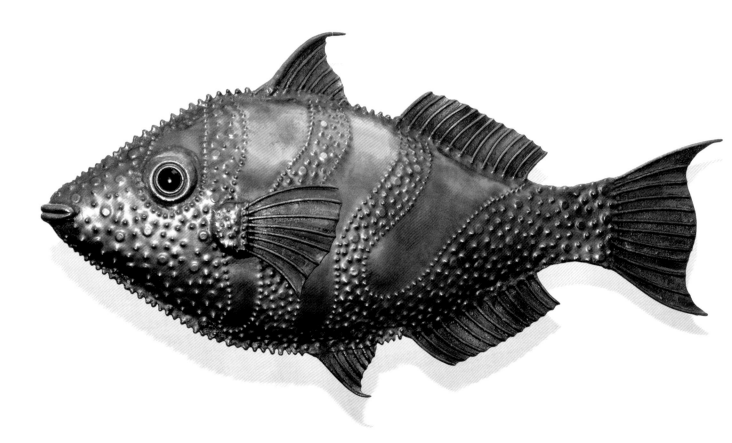

The work involves:

- cutting, annealing, shaping and planishing two complimentary pieces of copper plate
- giving them surface texture
- joining them together
- bending and soldering copper rod to make fins
- forming an eye with a semi- precious stone (cabochon onyx)
- cleaning, colouring and polishing the finished work.

A fish was chosen as a project suitable for beginners who have learned some of the basic skills of manipulating copper. The fish is based on an imaginative amalgam of a blue trigger fish and a filefish, which in nature could be expected to have well-defined colour zones. These can be represented in texture. The piece is designed to be hung on a wall.

The fish is constructed out of two panels of copper sheet, raised by hammering and joined along their edges by soldering along a flange. The skill is in raising and decorating the two panels to the same shape, and joining them together neatly and with precision. The fitting of the fins and the tail, the eye and the mouth are integral to the overall design of the piece.

The tools required for this project are virtually the same as those used in the making of the dragonfly (Chapter 4). However, because of the heat required for annealing the large surface area of some of the components, a blow torch fitted by a flexible hose to a full-size cylinder of propane was used.

PLAN, MARK AND CUT

A full-size drawing is essential. It will show the outline of the front panel of the fish, the design and location of fins, tail, eye and mouth, and the surface decoration.

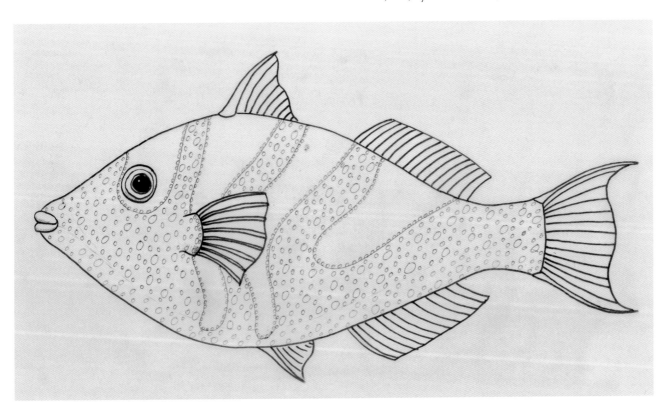

The sculpture is 45 cm (17¾ in.) long and weighs 850 g (1 lb 14 oz). The design is drawn on paper at full scale.

The rough shapes of both panels are cut from the sheet with a pair of tin-snips, with one arm mounted in a vice and the other lengthened with a pipe to increase the cutting pressure and provide more control.

Tight radii and small angle curves are cut with jeweller's snips with curved blades.

We have made a sculpture large enough to show details, for example the fins, and yet convenient to handle on a modest-sized bench.

A card template of the finalised shape (minus the fins and tail) is cut out, and this is transferred to flat copper sheet (0.8 mm) from which two copper blanks are cut (above). In this case, scrap copper sheet from a hot water tank is being used. If you use scrap copper sheet, you should make sure the best surfaces are on the outside. Remember that the two pieces have to be mirror-images of each other.

The cutting of the two blanks needs to be accurate, since they have to be raised to the same size and joined along their edges. Using the large tin-snips with one handle mounted in the vice is an advantage, since it allows a large sheet to be manipulated. Note that the tin-snips should be kept sharp. Cut as close to the outside of the line as is practicable. Use jeweller's snips with curved blades to cut shapes with tight curves, such as around the head and the tail (above right).

TRUE AND ANNEAL

The preparation of these two panels before they are 'raised' is very important. Before they can be filed to the same size and shape, they need to be flattened by gentle hammering on a flat surface, first with a wooden mallet (opposite, top left) and then with a metal planishing hammer (opposite, top right) to true the edges.

To ensure both panels are exactly the same shape and size, they are held tightly together between roughly-shaped wooden boards in a vice and the edges filed. Hold the file at an angle and file along the length of the plates (opposite, bottom left).

Before the panels are raised, they both need to be annealed. Since it is important each panel is evenly heated over its entire surface, work methodically from one end to the other, playing flame over metal until it is cherry-red (opposite, bottom right). The heated areas become discoloured with black copper oxide, and on a large panel this shows you what remains to be heated.

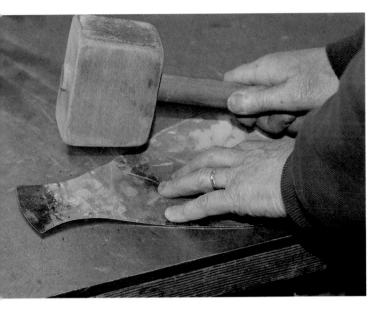

The panels are roughly flattened with a wooden mallet ...

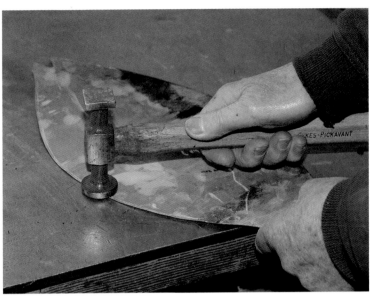

... and the edges trued with a panel beating hammer on the steel plate.

The edges are filed true.

Using tongs, quench by immersing in cold water. Quenching takes seconds. Thereafter, wipe as much of the copper oxide away with a damp cloth as possible, thus making the piece more pleasant to handle.

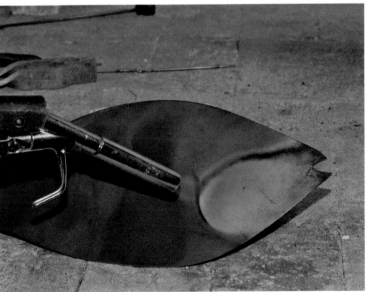

Before the panels are dished or raised by beating, the copper must be made pliable by annealing. Annealing occurs around 400°C (752°F). At this temperature the colour changes into a recognisable cherry-red. On cooling, black deposits of copper oxide form on the annealed area.

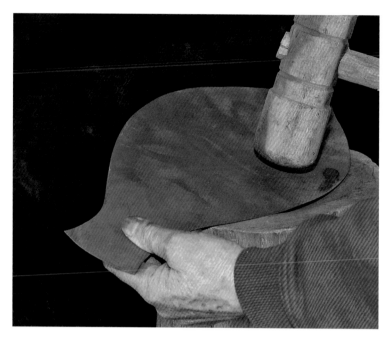

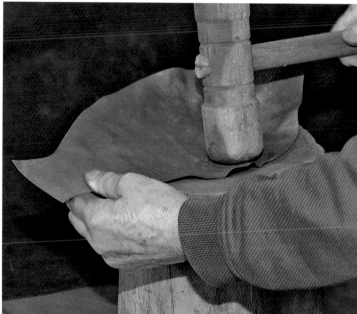

This is the most skilled part of the operation: the copper 'migrates' towards the edges, without seriously thinning the panel in the centre.

However, this re-distribution of copper from the centre distorts the material along the edges. Distortions have to be removed with very gentle beating along the edges.

RAISE THE PANELS

The shape of the fish is roughly that of a pair of raised elliptical panels welded together. To create these three-dimensional shapes the copper has to be raised into two shallow bowl-shaped panels, 'front' and 'back', of ovate shape. Each panel is held over a dished wooden anvil and gently beaten from the centre outwards towards the edge with a wooden bossing mallet (above).

Having trued the edges, the body panels are further beaten to smooth out their surfaces, this time against a straight wedge so that its longitudinal shape can be formed (right).

The body is reversed onto a mandrel and the surface that will be seen ('front') and the edges are further worked by gentle hammering with a planishing hammer (opposite, top left).

Use your fingers to feel for unevenness and check that the shapes are as desired. You need to have a clear idea

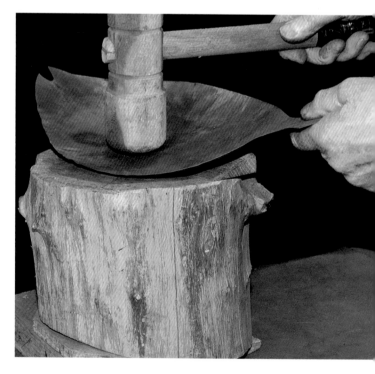

The flat surface of this anvil aids with the shaping of the relatively flat areas around the tail.

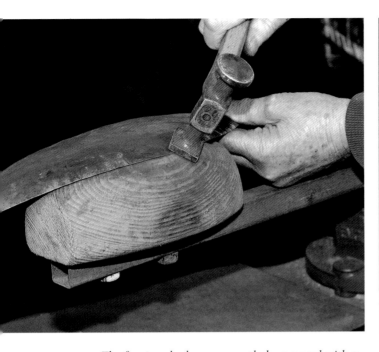

The front and edges are gently hammered with a planishing hammer on a homemade elliptical wooden mandrel bolted to an arm held in the vice. This process evens out and smoothes the surfaces.

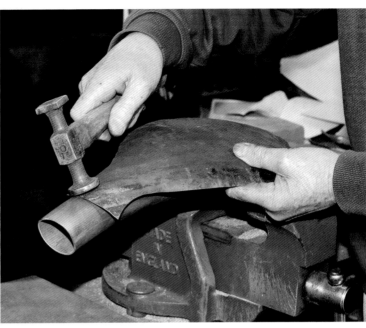

The tighter radii on the surface (around the tail, for example) are planished on a curved metal mandrel made from a length of discarded pipe held in a vice.

of the final shape you are trying to achieve: you may wish to cut templates out of thick card to check the curvature of the panels.

Serious mistakes at this stage can be rectified by annealing and hammering wayward panels with a square-ended carpenter's mallet on a flat surface. The copper sheet may begin thinning, and the panels will need to be re-marked, cut and trued to shape before another attempt is made to raise them. When raising two sides of a piece (as is the case here) remember that each piece is 'handed', a mirror image of the other.

DECORATE

The patterns on the body of this fish are represented by repoussé work, in which a texture of spots in relief is chased from the inside using metal punches to simulate a pattern, which in nature is one of colour.

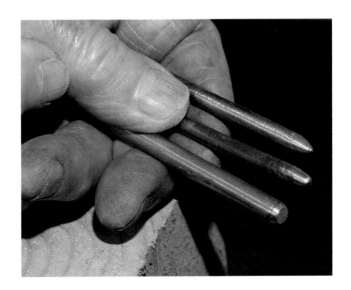

The spots are raised using three punches of differing size and profile, formed from steel rods (or nails) filed or ground to an appropriate shape.

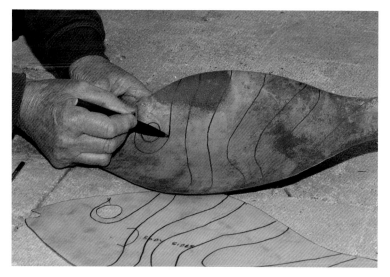

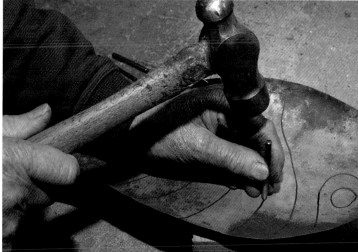

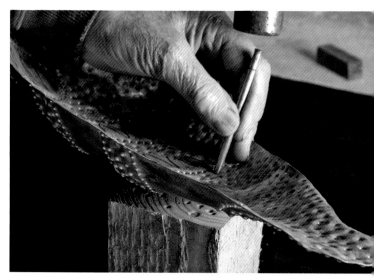

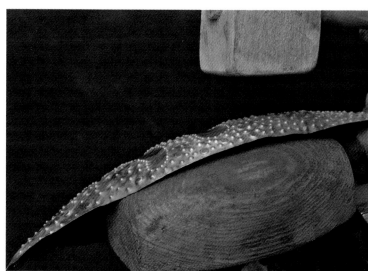

The first task is to transfer the pattern to the inside surface: this requires the use of tracing paper and the original drawings, and is straightforward (above left).

In this case, three different punches are used to raise a pattern on the front.

The effect of each punch is tested on a small piece of scrap copper sheet, the same thickness as the fish body. Use this test to learn how hard to hammer the punches and avoid making holes in the metal (above right).

The spots are raised with the front panel resting inside-up on the end-grain of a flat softwood block. The boundary lines between spotted and unspotted zones are demarcated with the finest punch (right).

Any distortion to the shape of the piece is easily restored by gentle hammering on a convex wooden mandrel held in a vice (bottom right).

Top right: The body is supported on a softwood block and the zones demarcated with a fine punch.

Middle: Holding the panel in oblique light makes this task easier. Notice also how raising the spots has inevitably distorted the shape of the piece.

Bottom: The original shape is restored by gentle hammering.

FINS

It is necessary now to make the fins and the tail, since space for these have to be accommodated between the two panels. The fins are made by soldering copper wire to sheet.

Cut out a piece of flat sheet the size and shape of each fin and file the edge. Cut sufficient pieces of copper wire to make the spines and taper them at one end. Give the pieces of wire some curvature, lay them on the appropriate plates and solder them into position (right). Trim the ends and file the spaces between the spines. Once made, the fins are placed on the original plan to check that they conform to the design (middle, right).

The fins can be twisted to simulate a swimming motion, but this is better left until they are fixed to the body. Their relative positions on both panels need to be marked.

JOINING PANELS

Soldering the two panels together results in the piece becoming very hot. There is a danger that, if cooled too fast, the air inside the structure will contract and the side walls collapse. To obviate this predictable effect, it is worth making at least one pressure-relief hole in the piece. Select a place on the back panel that will be out of view. Drill a series of 3 mm holes in the form of a circle (bottom right), remove the web between the holes with jeweller's tin-snips, and tidy the edges with a grinder or file.

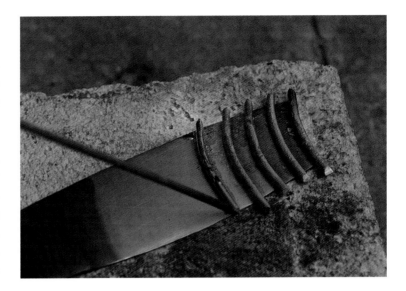

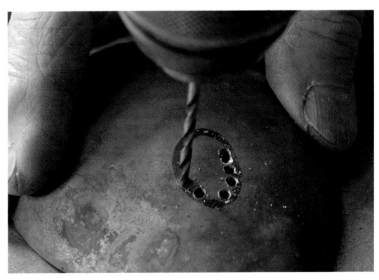

Top: Fins are made by soldering copper wire to sheet, trimming the ends and filing the spaces between the spines.

Middle: The fins are laid out on the original drawing to check their size and shape.

Bottom: Creating a pressure-relief hole.

We now come to one of the key stages in the sculpture, namely joining the two panels of the body shell together. This is done by forming a flange around the edge of each panel, and soldering the flanges together. The flanges made on both pieces need to be mirror images of each other and be of the same dimensions, before they are joined. At the same time, they need to be constructed so that the rear panel contains openings for the fins and tail. Note also that the flange does not extend towards the mouth.

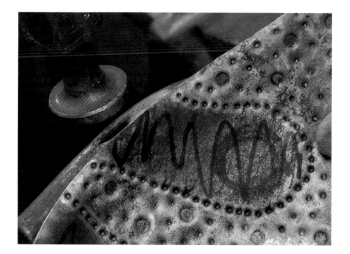

Top: This process to form the flanges begins by forming a flange along the inside edge of each panel, using the planishing hammer. The piece is held on a curved metal anvil (a slightly curved, scrap steel rod).

Right: Raising the spots and making the flanges can deform the longitudinal curvature. This can be rectified by gentle hammering.

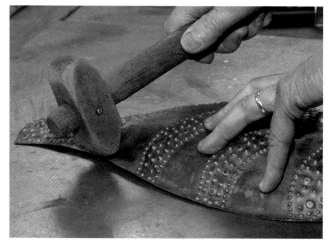

Below: Notice that the rear (furthermost) panel has had its flange made deeper where the fins will be located. It also has less patterning as this will not be seen when it is hanging on the wall.

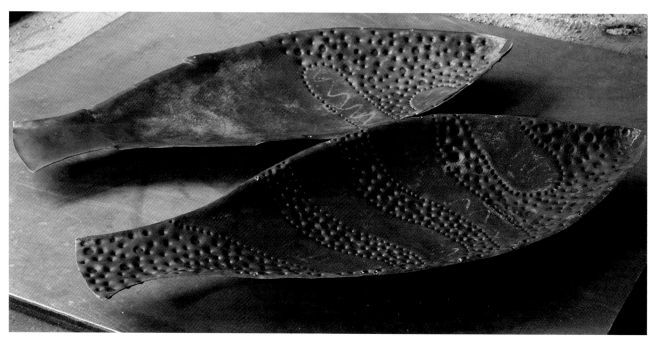

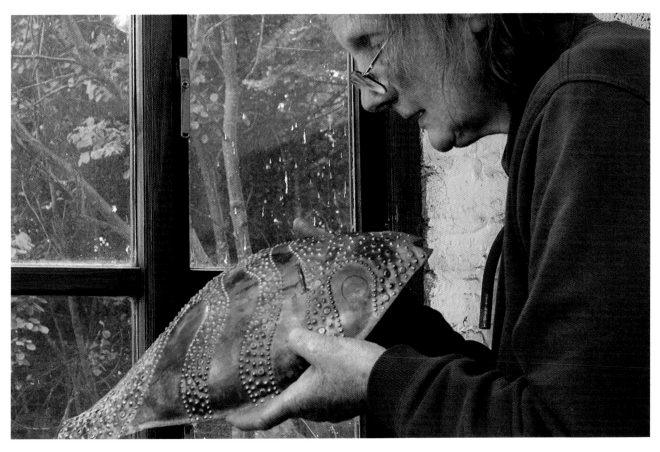

The piece is scrutinised frequently during the making of the body for its flatness, overall shape and precision.

When the flanges are complete, set each panel on the flat steel plate and correct any change in the overall shape caused by raising the spots and hammering of the flanges. The shape is restored by gentle hammering along the edges of the affected part until the panel lies flat and true on the steel plate (opposite, middle).

The two panels should be frequently matched and adjusted as necessary. This is especially true before the next step, which involves joining the two halves. Remember to anneal between operations. Examination, using eyes and hands, is the best way to detect faults.

The two panels are brought together, the front on top, and will be held in position during soldering by short lengths of 1.5-mm copper wire threaded through 2 mm holes drilled in the flanges. The positions for drilling are carefully chosen to avoid the areas where fins and tail will be attached, and the flanges in the front panel are drilled first (right).

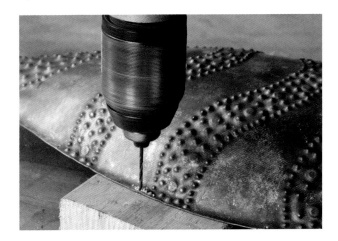

The edge of the front panel is trimmed to its final width, and holes are drilled to take the wire ties that will hold the panels together for soldering.

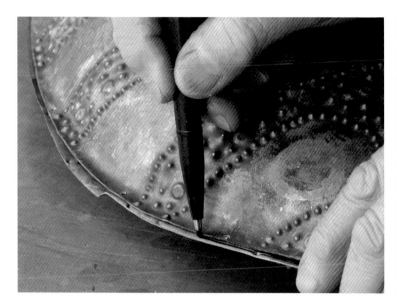

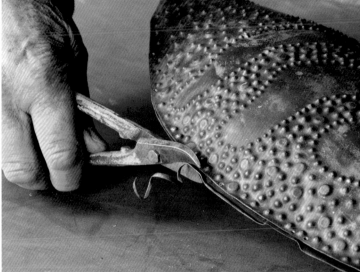

The front panel is laid on the rear panel and any surplus metal on the rear panel is marked for trimming. The holes are also drilled through the rear panel using the front panel, which has already been drilled, as a template.

The edges of the rear panel are trimmed and drilled (top right). Note that the flange does not extend to the tail and that openings on the rear panel for the fins are hammered to fit the contours of the fins.

Short lengths of copper wire are threaded through the holes and the copper wire is squeezed (rather than twisted) with pliers so that it can be undone after soldering. The panels are further clamped together (opposite, top left). Before soldering the two panels together, the access points for the fins are again tested to check that they will accommodate the fins, and are opened up as necessary.

The first stage in soldering is to form 'tack welds' close to the tie points, but not on the tie wires as these have to be removed (opposite, bottom left). This is done by playing the gas flame on a short length of flange and, when at a suitable temperature (a cherry-red colour), touching the tip of a solder rod on to the joint and allowing a drop of molten solder to flow into the seam, which is squeezed together with pliers while still hot (opposite, bottom right).

This process is repeated at intervals around the edge of the piece so that the two panels are firmly fixed together.

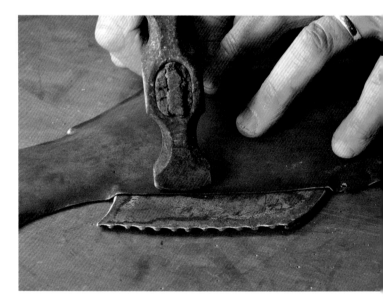

The fin housings on the rear panel are trued to the shape of the fins before the panels are joined.

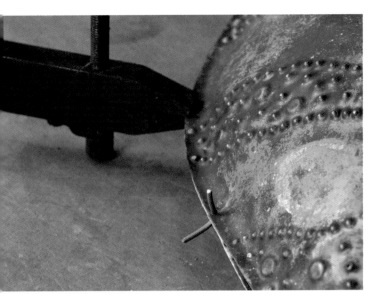

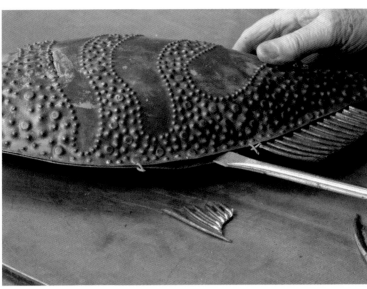

The copper wire (previously bent) is passed through both holes and squeezed together. Additional (heatproof) clamps hold the flanges tight together.

Note the position of the copper wire ties at either side of the fin.

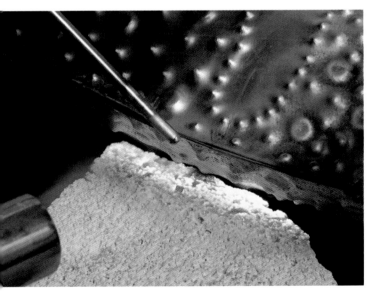

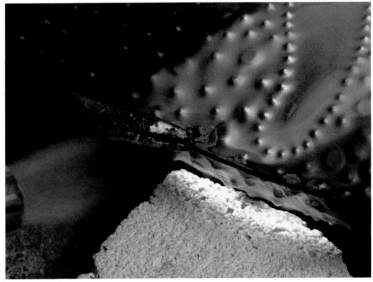

Before the two panels are soldered along their entire lengths, short tack welds are made at intervals to hold them firmly together.

A single drop of molten solder migrates by capillary action into the seam, which is immediately pressed together with pliers.

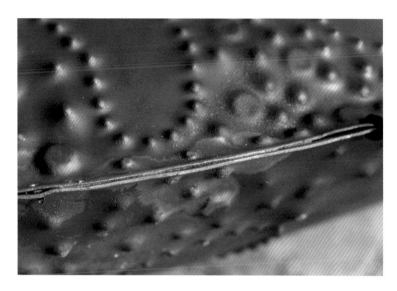

The tie wires can now be removed, the lengths of the seam soldered and the edges drawn together. Note the thin layer of solder between the cooling plates.

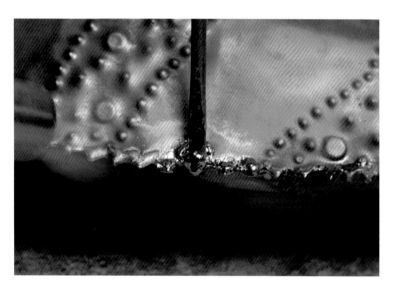

Removing unwanted solder is an important skill to learn. Heat the blob of solder until it is molten and scrape it off the sculpture with a flattened steel rod or fine screwdriver.

As the panels are now being held together with tack welds, the wires can be removed and the whole seam can be soldered. Over a length of a few centimetres, both flanges are heated to a cherry-red. The solder rod is introduced into the stream of hot gas and is briefly touched against the heated joint, allowing molten solder to flow into the seam by capillary action. The red-hot edges can be crimped together with pliers while they cool. You should end up with a line of solder between the cooling panels that is so thin it is hardly noticeable. Any part of the joint that is too wide can be re-heated and squeezed with the pliers.

When you have finished, make sure that there are no unsightly blobs of unwanted solder on the flange, and the holes for the fixing wires are all filled with solder.

Soldering completed, the piece is quenched in cold water, which is poured over the subject carefully so that the rate of cooling is controlled. This is important in a hollow work with thin walls that contains a lot of air; a sudden drop in temperature can cause a partial vacuum and the collapse of the structure.

Soldering is a key process and it takes skill to place the right amount of solder in the correct place. Practise soldering on scrap pieces until you are confident that you can predict, and thus control, where and when the molten solder will run.

FINS, TAIL, EYE, MOUTH, SPINES

The sculpture would not be complete without those elements that breathe life into it. Thus, the parts that allow the organism to move through the water, see and feed are a crucial part of the work. These pieces (fins, tail, eyes, mouth and spines) have to be correctly positioned and of an appropriate shape and size to represent organs that are functional in real life. Each presents its own challenge. We start with the mouth.

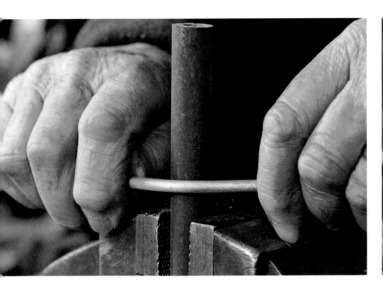

The mouth consists of two matching lengths of copper pipe bent around a former ...

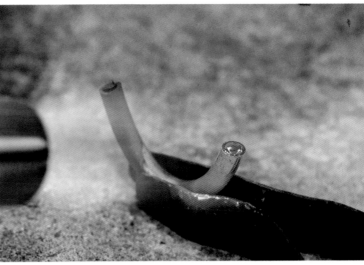

... with their hollow ends blocked with soldered wire.

The mouth is made of two lengths of 5-mm copper pipe representing lips, bent to a common shape around a former, with their hollow ends blocked with 3-mm wire soldered into place (above left and right).

Each end is tapered with a file and the two lengths are soldered together, leaving the lips separated by a narrow gap. The completed mouth is offered up to the sculpture, adjusted in shape, wedged into position and soldered (right).

The absence of any solder in the space between the lips is suggestive of an organ that opens and closes, and is a good example of the attention to detail that can bring the piece to life.

Spines along the back and the belly are made by cutting notches with a piercing saw along the joining flanges. To facilitate this, the body of the fish is held vertically and the flanges gripped in the vice while sawing takes place. The notches are filed, closed and held together with a small drop of solder dripped on to the red-hot spines. This is a difficult operation to regulate and excess solder will be deposited on a spine.

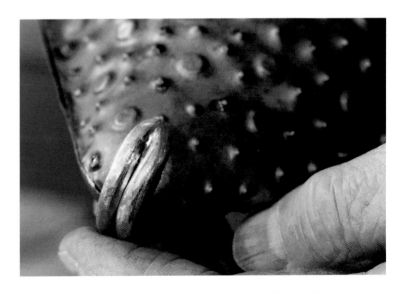

The two lengths are shaped, joined at their ends and then soldered into position.

As described on p. 77, the fins are made by soldering wire to sheet, trimming the ends and filing the spaces between the spines. Fins are inserted into the slots left for them around the edge, and the flanges lightly hammered on the back panel to ensure a tight fit. The fins are soldered into position, resting on a kiln brick, the solder being introduced along the back. After the back side of the fin is soldered into position, the copper sheet making up the flange on the front panel is compressed with a pein hammer between the spines of the fin. Small quantities of solder are dripped along the edge to seal the fin into its housing.

The fins along the back (dorsal) and under the belly (ventral) are fixed in this way: the pectoral fin, which lies on the flank of the fish behind the head, presents a different problem and is described on p. 86.

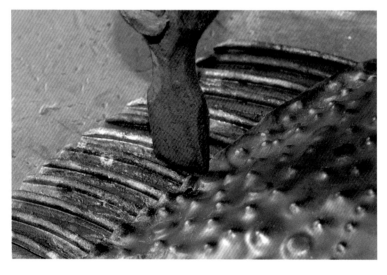

The fins are attached to the body. They are fitted into the slots left open for them in the flanges ...

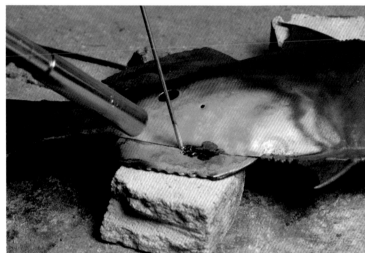

... and soldered on the reverse.

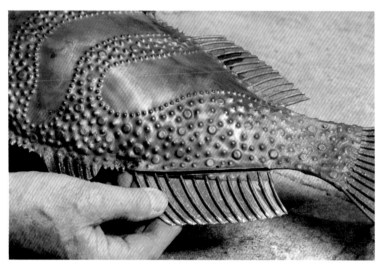

The flanges on the front panel are compressed with a pein hammer between each pair of spines while the fin is resting on the edge of a steel plate ...

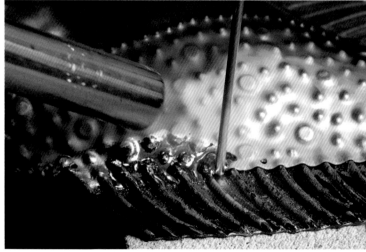

... and then soldered to the body.

The eye is a black onyx semi-precious stone, cut as a 15-mm cabochon and set within a fine copper ring.

The eye socket is made by raising a column of copper sheet over a 25-mm tube former, splaying the walls outwards and cutting them to fit the profile of the head at the point of attachment.

The ring is soldered onto the socket before fixing to the fish. The socket is soldered to the head and the head is quenched.

Only one eye is visible on this piece. It consists of a socket (right) which holds an onyx cabochon within a ring of copper wire.

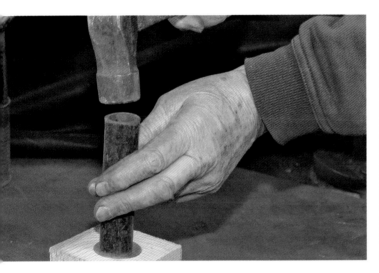

The socket is simply raised by hammering a disc of copper with a metal tube ...

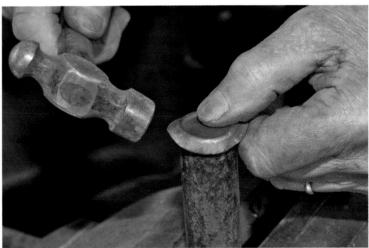

... and shaping the edges around the top of the tube to form a bowl shape. The sides are then trimmed to fit the profile of the fish's head.

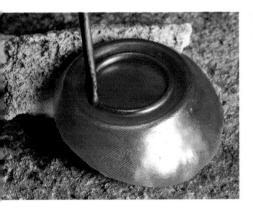

The wire is soldered to the socket ...

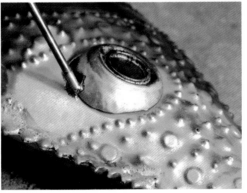

... which itself is soldered into position on the head.

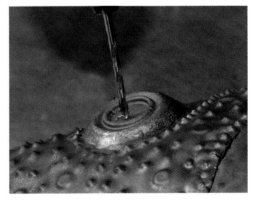

Because the eye socket is now a sealed cavity, it could distort under heat. Thus, a small hole is drilled to release heat.

A small hole is drilled in the socket to allow expansion and contraction of the air within the socket (see p. 85). The bead is not glued in position with araldite epoxy-resin until the sculpture has been cleaned and polished.

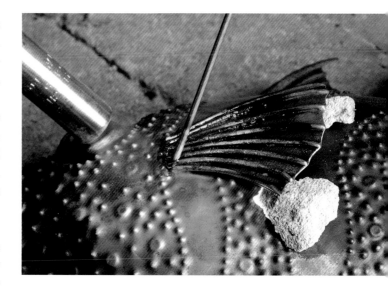

The pectoral fin is fixed into position after the eye socket, because it would be the more vulnerable when the latter is soldered. Decide where the fin is to be fixed and cut a small slot to take the end of the fin. This can be done by drilling a row of small holes and cutting the webs between them (see p. 77).

Make a small cover for the root of the fin, textured to match the body, and solder into position. If the cover deforms while being soldered, a little gentle tapping with a hammer will help it fit snugly against the body.

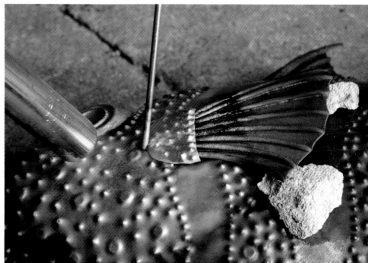

Right top: The pectoral fin is supported on scraps of thermal brick and soldered into position.

Middle: After the fin has cooled, the covering for the front of the fin is set in place and soldered.

Bottom: Notice how the individual spines are clearly separated from each other at their roots, and have not been subsumed by a mass of unwanted solder. This attention to detail demonstrates the high quality of workmanship that can be achieved using scrap materials.

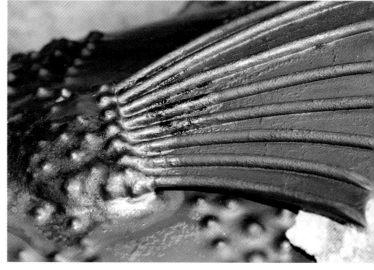

HANGING CRADLE

This sculpture is designed to hang on a wall. A simple cradle made of copper is soldered on to the back of the piece to hang and level it according to choice (right).

The centre of the cradle is located at point-of-balance of the fish, with about 5 cm (2 in.) latitude on either side. Provision is made for small pads of leather or rubber to be glued to the cradle to prevent rubbing on paintwork.

FINAL SHAPING, CLEANING, COLOURING AND POLISHING

Once all compontents are assembled, modifications are made to the shapes of the fins and the tail in the forms of gentle curves, as might be observed on a fish swimming. The effect gives the piece a feeling of movement (see p. 89).

The various soldering and quenching operations result in a piece with unsightly colours. These have to be removed, the surface stripped back to pure copper and deliberate colour applied. The body is cleaned with vigorous wire brushing to remove the various layers of copper oxide. In this case, a circular wire brush, held in

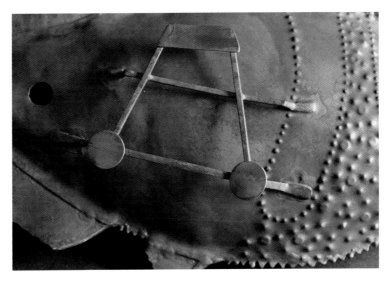

The circular coppers are for small pads of leather or rubber, to prevent the piece marking the paintwork when hung on the wall.

the jaws of a drill, is used to clean the large areas of the body and fins (below right). Note that the rotation is always aligned with the grain (i.e. brushing away from exposed edges) to avoid snagging the fins and bending them. Smaller, less accessible areas are treated with handheld wire brushes, wire wool or emery cloth.

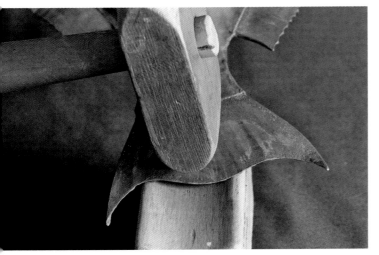

The tail and the dorsal fins are held over a hollow wooden anvil and beaten gently with a mallet to the required shapes.

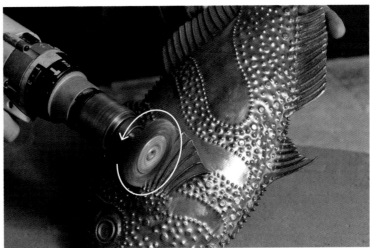

The body is subjected to quite vigorous wire brushing. Do not use undue pressure as you may dent the body.

The final appearance of the piece depends on its colour and this is achieved by heating copper in air. This causes the surface to become oxidised, the resulting colour depending on the amount of heat applied.

The skill of the artist is to know what sort of effect is needed, and then when to stop applying treatment. Remember, the treatment can be reversed; the piece can be wire brushed back to raw copper again and a second attempt made. Application of beeswax softens the rawness of the colouring and provides a thin protective layer, which slows down the natural surface oxidation that, in time, dulls copper.

If you find the techniques challenging but rewarding, we suggest you consider the next project, which introduces a set of quite different problems. For the owl, you will need more space and more tools, many of which you can make yourself. Alternatively, you can use the fish to give you inspiration for your own project, using the skills and techniques you have learned on this relatively simple, yet challenging, piece.

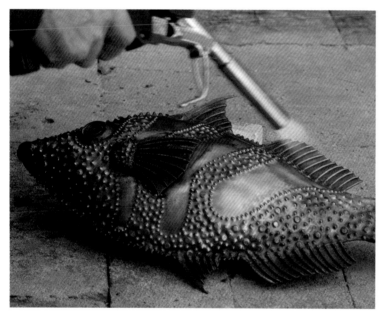

Washing the surfaces with flame can infuse the piece with scintillating and brilliant colours.

Right: The beeswax is applied thinly with a brush, and rubbed down with a clean cloth after drying for about 15 minutes.

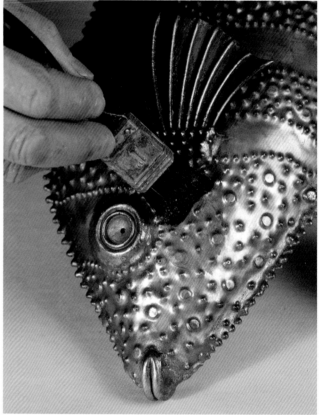

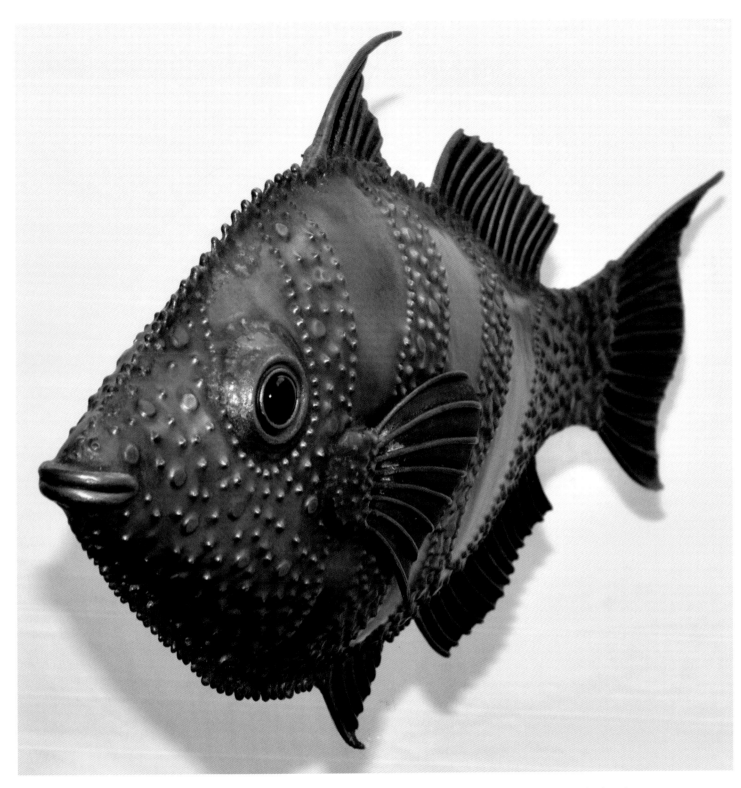

The coloured, waxed and polished sculpture,
photographed two years after it was completed, shows
how the original colours have withstood the test of time.

Owl

INTRODUCTION

This final instructional chapter reviews some of the techniques used to make a large (55 cm, or 21½ in. tall) and heavy (13 kg, or 28 lb 11 oz) free-standing sculpture in copper. This is an ambitious piece of work which requires space, skill and some extra items of equipment (most of which you could make yourself). The chapter demonstrates the potential of copper for creating complex and demanding sculptures, and we introduce it in the knowledge that it probably represents a challenging step. However, we believe there is merit in showing what can be achieved with this most forgiving of metals, and that some of the techniques described may well help you to solve problems you will meet when you decide to design your own pieces.

The subject chosen is an intelligent, alert, nocturnal woodland raptor – a Tawny Owl.

This species is highly specialised to hunt silently, to locate and to kill its prey in the complex labyrinthine environment that is woodland at night. For this it needs:

- acute sight
- directional hearing
- short, silent wings
- sharp multi-purpose talons
- good insulation.

The owl's structure and appearance have evolved to meet these needs. For example, its eyes are so large

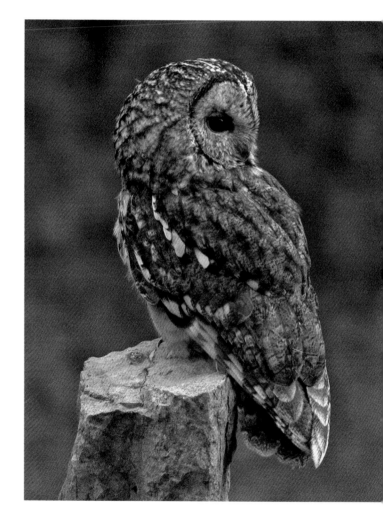

Notice the prominent facial disc holding the eyes and the bill, and that the head is rotated 180 degrees from the front. The head appears large compared to the rest of the body because of the dense mass of insulating feathers on it.
Photo: © David Williams.

they cannot turn in their sockets. To compensate, the bird can rotate its head through 180 degrees. The shape of the face is modified to intercept the faintest of noises, and the resulting facial disc concentrates sound in the two forward-pointing ears, which themselves are asymmetrical to improve direction indication. This system in another nocturnal owl (the barn owl) has been shown to locate the origin of a sound to within +/- 10 in complete darkness.

Moving silently through a tangle of branches requires short, strong buoyant wings, and the feathers of the Tawny Owl's wings are specially adapted to move silently over each other. These same feathers, along with those on the back, the belly, the head and the legs, must be able to shield the bird against cold, wet or inclement weather common at our latitude in winter. Finally, among the most specialised of instruments are the talons. These are multi-purpose precision tools for supporting the bird at rest, for grasping and penetrating the skin and bones of the prey to reach the vital organs, for releasing the prey and for preening. The talons are attached to a set of muscles and tendons that can contract and apply enormous pressures at the talon tips.

These are the characteristics embodied in copper in this work. There are different approaches for suggesting, for example, feathers (see Michael Brewer's 'Little Owl' in Chapter 7, p. 121); it is all a matter of choice.

The making of the owl took several months and hundreds of hours of careful and skilled work, and it is outside the scope of this book to describe in detail every stage involved. We thus want to concentrate on a few key points which you might care to consider when designing your own pieces. These are as follows:

* Specialised equipment for a large, free-standing sculpture
* The need for, and design of, the base
* The making of a body shell
* The importance of the feet
* Treatment of feathers and how to fit them to a complex, rounded shape
* The setting and modelling of the head
* Heat management
* Size and bulk.

We will consider these key points in the order in which the owl was constructed.
* Base and structure
* Legs, head and feet
* Feathering
* Cleaning, colouring and polishing.

When completed, the owl stands 50 cm (20 in.) tall and weights 13 kg (29 lbs).

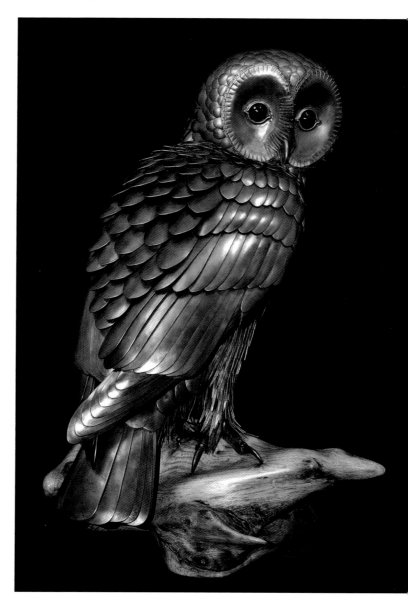

TOOLS AND EQUIPMENT

Additional tools and equipment are required beyond those needed for the fish (Chapter 5). In contrast, the owl is free-standing and heavy. It sits in a precise position on its base, from which it has to be easily moved during construction. The sculpture consumes a large quantity of copper sheet in hundreds of components, each of which is cut and shaped with precision, soldered into position, and then cleaned and polished.

BENCH

To facilitate handling the piece, holding it fast for heating and soldering while assessing its appearance from all angles, it is very useful to have some form of rotating turntable covered in heat-resistant, insulating kiln bricks. This could be a free-standing rotating modelling stand, as shown right, or a simple rectangular bench that you can walk round.

BLOW TORCH

It was necessary to heat each of the owl's components for annealing, and then again when being soldered into position on the piece itself. As the sculpture gathered bulk with the addition of new features the management of heat became an increasing problem. Copper is an effective radiator of heat, and maintaining adequate temperature at the point of soldering required both ingenuity and a considerable heat source. Whilst the smaller pieces illustrated in this book could be heated to an appropriate temperature with a domestic plumber's soldering gas cylinder, this piece needed a greater mass of air and gas to be directed onto the weld site. Therefore, a powerful blow torch and large reserve of gas at constant pressure was required.

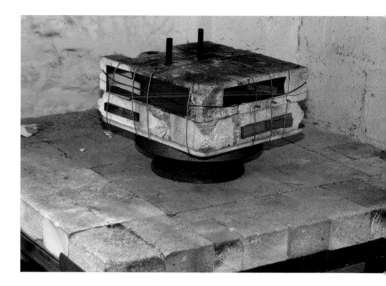

This 1 x 1 m (39 x 39 in.) bench is faced with heat-resistant insulating kiln bricks and can be rotated by hand. It is a safe site for soldering. The smaller plinth of similar bricks is set on a freely-rotating iron modelling stand, convenient for adjusting the position of the piece during its construction. Note the two tubes inserted into the bricks, which are set to receive the owl's leg extensions. An extractor fan in an aluminium hood (not shown) is suspended above the table and vents soldering fumes to the outside.

POLISHING

Because of the owl's final bulk, mechanically-driven wire drill brushes (circular, cup, end) mounted on the end of a flexible drive shaft were invaluable for removing all of the accumulated copper oxides.

BASE AND STRUCTURE

The base is a critical element in the sculpture. It has to be proportional, credible, interesting and substantial.

In this case, an old Scots pine stump was selected and sawn in half. Scots pine stumps are naturally resinous, dense and thus heavy: attributes needed to provide a firm plinth for the completed work. A block was fitted to the sawn face, and the base was held in a vice for shaping. The stump was carved down to sound wood.

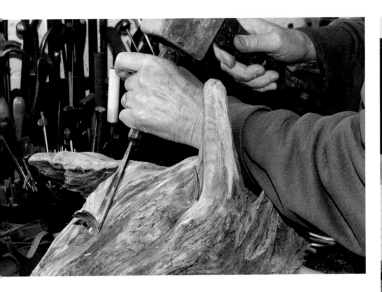

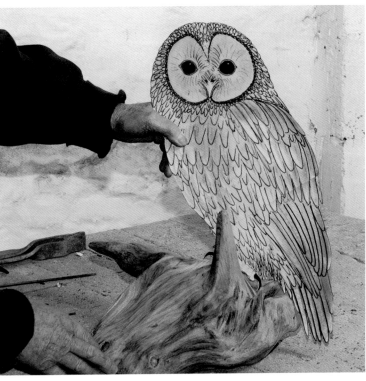

The pine stump was halved, and a block of wood screwed to the base. This allowed it to be held firm in a vice for dressing with a gouge and finishing with sandpaper. The root that appears to be vertical was later removed.

A cardboard cut-out was used to decide the size of the sculpture and its scale in relation to the base (shown above right).

The final position of the bird standing on the base was decided later. However, because the process needs the piece to be mounted and dismounted from its base many times during its creation, this has to be taken into account early on.

The body shell was beaten out of two sections of copper sheet, soldered along their length and strengthened by an internal framework which takes the weight of the head and the legs (right).

The framework, of small diameter copper tube with stainless steel rod inside it, was extended to support the head. The shell was held against the cardboard cut-out to check for its overall dimensions.

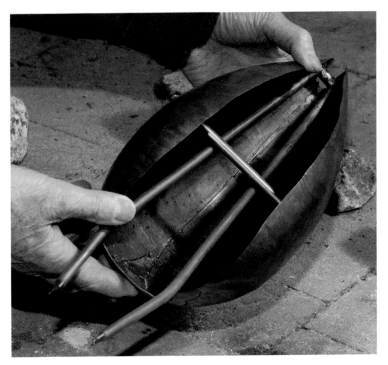

The body shell (made from two raised copper plates soldered together) incorporates an internal framework to ensure a rigid structure capable of supporting 13 kg (29 lbs) of copper.

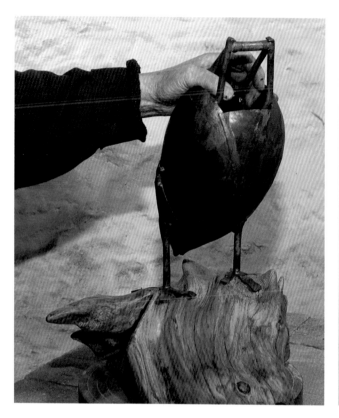

Temporary legs have been spot-soldered on to the flanks. Feet, made from copper sheet, have been attached to the legs. The best stance of the bird on the base was decided and marked.

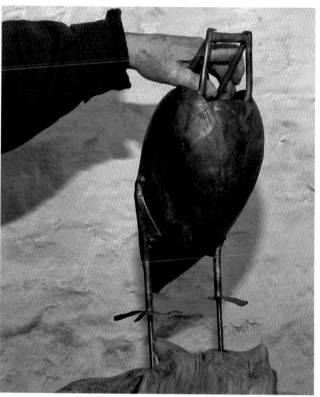

In this photograph, legs have been extended by threaded steel rod, which fits holes drilled in the base to accept them. Facilities were made on both welding benches to hold these rods.

LEGS

Temporary legs were made of copper tube with feet of flat copper plate. These were tack-soldered to the body, and the body stood on the base to determine its best position and stance (above left). Considerable care was taken with this stage, adjusting the legs and the body angle so that the bird appeared to be comfortably perched on the base: this stage is critical to the integrity of the whole work. Once the stance was optimised, the base was marked for drilling. The legs were then re-made, copying the prototypes exactly, but with stainless steel threaded-rod included in the tubes as reinforcement. This protrudes through the bottom of the feet, and will (when the sculpture is complete) be used to fix the bird to the base with nuts. The new legs were securely soldered to the body of the bird, readjusted to get the precise stance correct and then the holes were drilled through the base into which the threaded rods were fitted (above right).

Holes at equivalent distance were also drilled into the refractory bricks on the turntable or bench and fitted with steel pipes, which hold the bird by its leg extensions. The bird can now be switched between the base and the bench. All soldering and annealing takes place on the bench. However, it is important to keep fitting the sculpture to the base to check its appearance.

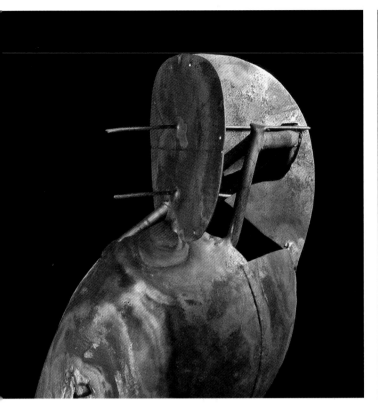

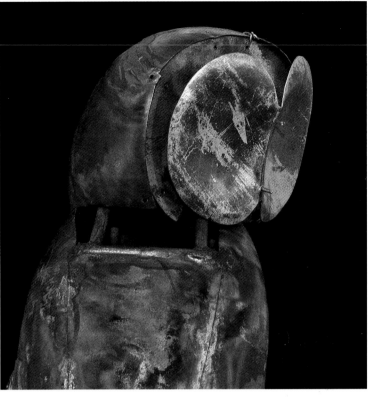

The two plates, at right angles to each other, provided the support for the skull and the facial disc. The two horizontal pins are there to aid the positioning of the facial disc.

The shape of the skull, made by raising two hemispheres of copper sheet, is evident. Note the drilled holes and the copper wire used to secure the hemispheres to the facial plate for soldering. In this photograph, the facial plate is held temporarily on the pins whilst the orientation of the face is decided.

HEAD

The next step was to create the structure to hold the head. A stance was chosen in which the bird would be looking over its right shoulder, with its head set at about 100 degrees from the front. In nature, the head of an owl can rotate 180 degrees, allowing the facial disc to detect and pin-point the direction of sound that could mean prey or threat. Having established the orientation of the face, the head was constructed. Two pieces of plate, set at right angles, were fitted to the top of the body to define the position of the head, one plate delineating the shape of the face and the other the dome-shape of the skull (above left).

The skull itself was made from beaten copper plate, formed into a hemisphere fitting on to either side of the rearward plate and to the sides of the facial plate. Two pins in the centre of the face provided reference points for the setting of the facial disc. The main element of the facial plate was beaten from a single sheet of copper, drilled and fitted to the face over the projecting copper rods and was soldered to the head. The gap between the head and chest was filled with copper plates, thus creating a smooth spherical head joined to the edge of the facial plate.

On the back of the owl's body, the anatomy of the wing bones was approximated in copper tube and sheet. The tubes were annealed, bent and soldered to the body and provide soldering positions for the feathers. Thus each successive layer of feathers, when soldered to the tubes, lay in the correct orientation one to another.

FEET

The owl's feet consist of toes, skin, talons and feathers. The toes were braced with bent copper rod, soldered up the leg to form tendons. The skin was formed from thin copper sheet, the texture being produced by beating from the reverse side. The skin was soldered on to each toe, leaving a gap at the tip for the root of the talon to be inserted (below right).

The talons were formed from copper rod, cut, annealed, bent and filed into the particular shape that defines birds of prey talons, and soldered on to the toes. This requires considerable precision so that each is properly in contact with the wooden base (opposite, top left and right).

The leg feathers were drawn onto card to check for size and shape, copied onto thin copper sheet and cut as a 'ruff' or frill (opposite, bottom right).

After annealing, each set of frill feathers was fitted onto the legs using a slim hammer to make them snug to the contours of the leg, showing the tendons beneath. They were then soldered into position.

Right: Feet are vital elements in the anatomy of owls. Each toe is effectively an extension to a tendon reaching up to powerful leg muscles. When these contract, the feet close with a force powerful enough to drive a needle-sharp talon into the body of the prey. Modelling feet and legs accurately (as shown here) gives extra credibility to the work, even if the anatomical detail, such as the tendons running up the leg, is subsequently covered by, for example, feathers.

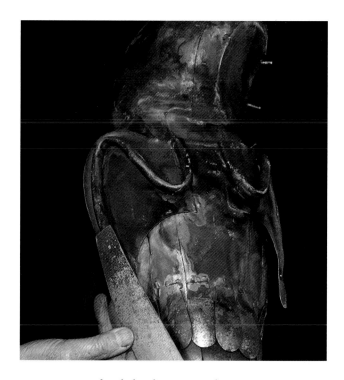

In nature, the skeletal structure that supports the wing muscles and allows the wings to fold is highly complex and refined. The curving pipe shown here simulates the bony wing structure to which the main feathers of the wing are fixed. Note also the wing plate, which maintains a gap between the wing and the underlying structure.

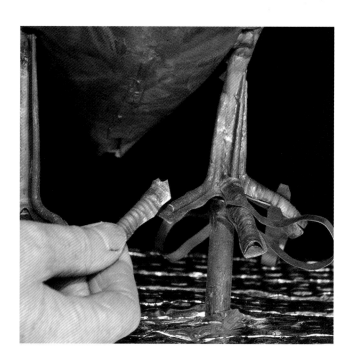

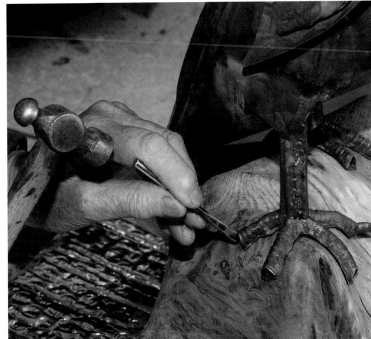

In nature, the shape of talons has been optimised by evolution to perform a particular set of functions. Rendering these accurately in the sculpture is aesthetically pleasing. In this case, they were made out of 7-mm copper rod, annealed, filed to a precise shape and then bent over a tapered anvil to the correct curvature.

The threaded bar leg extensions have been placed into the holes drilled for them in the base. The toes are gently hammered into close contact with the base and the talons inserted one at a time, gently crimped and soldered into position away from the base. When cool, the sculpture is returned to the base and the talons gently hammered into contact with it.

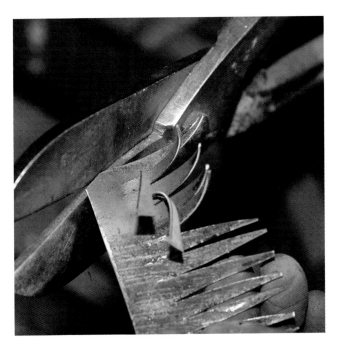

Right: Frill feathers are formed by cutting triangular-shaped slices from thin copper sheet. Notice the accuracy with which narrow fillets of copper have been cut out of the sheet with the large tin-snips, one arm of which is captive in a vice. The cutting edge of the snips is kept sharp.

FEATHERING

Once the basic shape of the bird (its head, body and feet) was completed, feathering could start. Because of the way feathers overlap each other like tiles on a roof, feathering started at the base around the feet and under the tail.

Feathers provide birds with a lightweight, flexible, heat-retaining, renewable covering. Raptors have at least four main feather types: flight; contour (body covering); down insulation; and crine (nostril and beak). Each feather type has a different structure and appearance. Clearly, in a sculpture as opposed to a model, the depiction of feathers is indicative.

The owl's feathers were made from copper sheet, whose thickness was determined by the size of the feather and its location on the sculpture. Thus, single

tail and flight feathers were cut from robust thicker sheet of about 1.2 mm, since these were sited where the sculpture would most likely be carried. In contrast, contour and down feathers (the latter cut as a frill) were made from thinner sheet, 0.7 or 0.8 mm. In the case of frills, annealing allows them to be fitted to some shapes without hammering.

The downy feathers that cover the legs, and the feathers under the tail, were among the first to be soldered to the body.

All the other feathers are precision instruments, and to look credible they have to be precisely formed. The edges of the copper blanks of the flight and covert feathers were filed true, annealed and then dished by gentle hammering on a wooden block (opposite, top right).

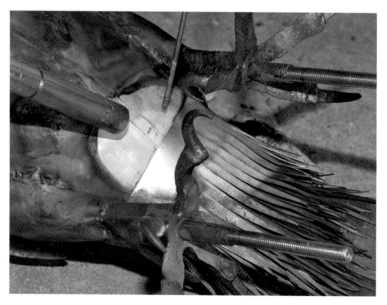

These feathers are fixed with a line of solder along their top edge. Care was taken to avoid heating the feet. Note the threaded bar extensions to the legs.

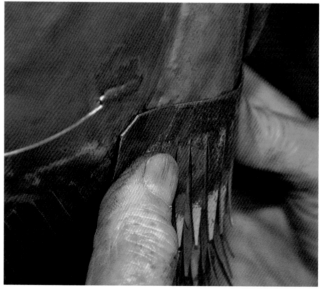

Feathered legs are a feature of some owls: feathers provide insulation for the rather poor blood supply to the feet in a bird that does not normally migrate south in the winter, and (as part of its hunting strategy) sits motionless for hours. The copper frills for the legs are built up in layers from the feet upwards. When properly annealed, they are flexible enough to be squeezed into position by hand. Note the short line of solder at the corner of the belly feathers

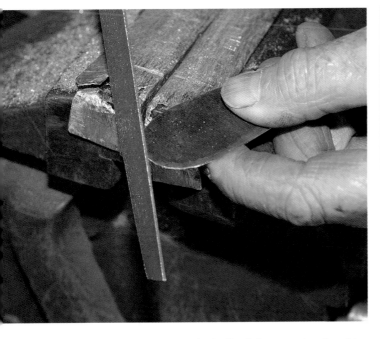

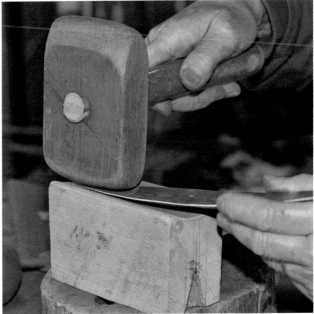

Single feathers make up the bulk of the covering for this sculpture, and each is made in the same way with the same attention to detail. Each is cut from copper sheet using paper patterns of various sizes. The edges are trued with a file before the blank is gently hammered into shape.

Bowing and dishing each feather blank, by even a small amount, helps keep the lie of the feathers even. Each is tailored to fit its particular location. In this case, a recently annealed primary wing feather is being dished along its length using a simple homemade mallet on a wooden anvil with a shallow groove carved along its length. At the same time, the feather is slightly bowed.

The single feathers were soldered on to the body in sequence, being held in position by steel clips, starting at the bottom and working steadily up to the head. The tail feathers were the first precision ones to be fitted.

Right: In this sculpture, the feathers were laid as tiles, overlapping each other along most of their lengths. To facilitate soldering, feathers were held in position using homemade steel clips. Note the pink area affected by heat, which is hot enough to solder. Notice, also, the build-up of copper oxides in the lower feathers. This same routine was followed hundreds of times throughout the entire sculpture.

The large primary flight feathers, which provide most of the motive force in flight, are visible on the edge of the wing on a perched bird. In nature, they are stacked together with precision, since they have to be called into instant use when the bird takes off. Care was taken to ensure that any imperfections in them were removed before they were soldered to the underlying structure, following careful placement, which has to take the stance of the bird into account.

Above: The primary feathers are those that stick out like fingers at the end of bird wings, and are the largest and stiffest of all flight feathers. In nature, they are precisely shaped to provide forward motion. When at rest, they are stacked as neatly as a folded fan, each protected by the one above, and ready to be deployed in an instant on take-off. It was thus important to check that each feather was precisely made and perfectly matched its neighbours, and this slight bump in one of them was not acceptable. It was removed by gentle hammering.

Left: At this stage, 6 out of 10 primaries have been soldered on to the framework of the right wing, the seventh being held in position by two clips for soldering. Note the neat way the feathers are stacked on each other.

In this case, the owl is twisting its head to its right, and this will influence the way the primaries of one wing rest in relation to the other. Here the right wing tip will overlap the left, reaching higher up the back. The secondary and tertiary feathers overlap the primary feathers, their actual positions being determined by the stance of the bird.

The upper back feathers were pushed up by the bent stance and twisting of the bird. As the feathering made its way up the body, the mass of copper in the whole piece increased. This created a problem when attempting to focus heat on one point for soldering, since the heat dispersed rapidly into the rest of the piece. Just increasing the heat output from the blow torch may be possible but not desirable if earlier welds fail and previously soldered bits fall off. A solution was to create a bridge of copper, only attached at either end, which provided insulation for the body and onto which feathers were attached (bottom right).

The feathering of the front of the bird kept pace with that on the back. Here, the effect of the bird looking back over its right shoulder required the feathers above the neck to follow a helical path.

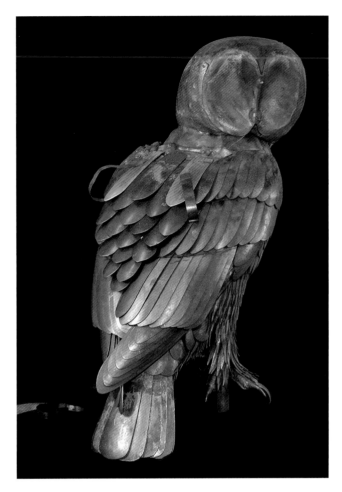

Top: Because the bird is depicted looking over its right shoulder, the feathers on the left side have been fixed slightly lower than on the right. It is this kind of attention to detail that gives the piece its authenticity and vitality.

Right: As the bulk of the sculpture grows with the addition of each feather, the dissipation of heat from each soldering point creates a problem. Because more heat has to be pumped into the structure to achieve an adequate temperature for soldering, there is a risk that previously soldered elements can be dislodged. A solution (as used here) is to create a heat 'bridge': a narrow strip of copper with limited points of contact with the body, on to which parts are soldered.

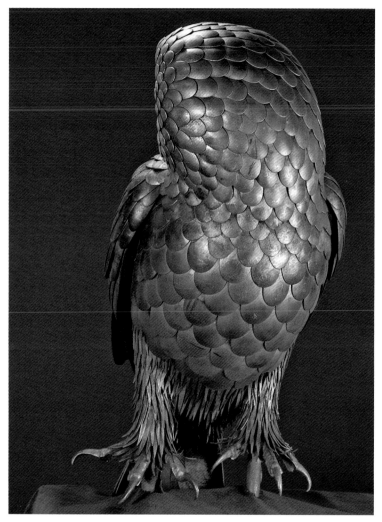

Fitting the feathers to the junction between the head and the body presented unique problems, because of the limited space and the sharp return angle. To facilitate the process, the sculpture was laid in a bed of stainless-steel mesh to give it heatproof support. A feather, held in position by a steel clip, was pushed hard into place by a steel rod in Sue's left hand, while she heated the top of the feather and its surrounds to a cherry-red. When that occurred, the steel bar was removed and a dab of solder placed in the joint (below).

Finally, the freshly-soldered and still warm feather was lightly tapped into its final shape. Feathering was taken up on to the head using the same techniques, a full line of feathers being aligned, held by clips and soldered in a single operation. Working on these increasingly tight radii and maintaining the symmetry while expressing the tilt of the head was not easy.

The setting of the facial disc is crucial to the character of the sculpture and the placement of the eyes determines the mood of the piece. However, the final facial disc cannot be fitted onto the head until the latter is completely feathered. Constant checks were made before completing the head feathers.

The gradual transition from broad feathers on the belly to narrow feathers around the face is evident in this view, which also shows how the downy frill feathers of legs and underbelly merge into the contour feathers above, and how the leading edge of each wing is held separate from the body itself.

The junction between the neck and the back represents a change in direction for the lie of the feathers. If not handled correctly, this could appear awkward on the sculpture, whereas in nature the transition is flexible and seamless. Thin copper sheet was used for the feathers in this region, and the blanks were annealed and bent roughly into shape.

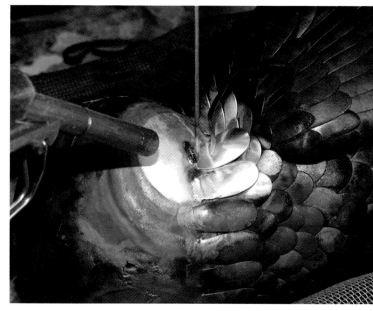

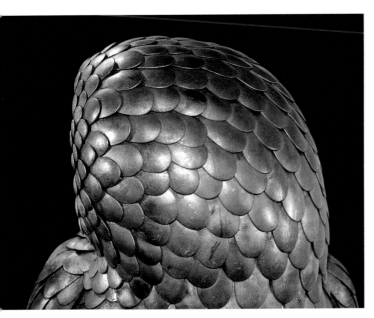

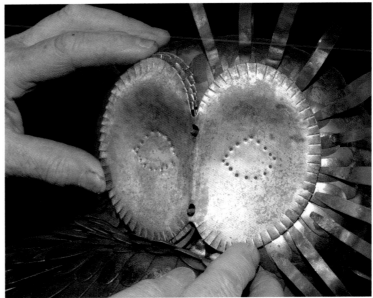

The lie of the feathers on the head produces a surface that is tactile and pleasing in its own right. It shows how the curvature of each feather adds to the overall effect and demonstrates the care and attention to detail needed for work of this quality.

The facial disc is among the most specialised and characteristic organs of owls, allowing them to coordinate and focus sight and hearing with extraordinary precision. The disc itself acts as a parabolic reflector, capturing and directing sound into the forward-facing ears. It is covered in at least four different kinds of feathers. Before the facial disc was fixed into its final position, it was tested against the last few rows of feathers before they themselves were soldered. The pierced holes mark the lines of the eye sockets, and provide air expansion vents for the facial disc during its attachment to the head, and for the positioning of the nasal hairs and beak.

In practice, feathering the head turned out to be an increasingly complex process as the facial disc was approached, requiring the fitting of a great many smaller and smaller copper feathers to a sphere of varying shape. In nature, the head is covered by hundreds of interlocking, overlapping feathers, each with a very narrow profile. In addition, the feathering on the head needs to link into that of the rest of the body. Here, the twisting of the head requires the feathers to follow a helical path.

The junction between the face and the main part of the skull is a particularly tight radius on which to fit stiff copper plates to act as feathers, especially where the head feathers interact with the facial disc. The feathers around each eye were all held in position by spring clips before they were soldered (above right). A number of layers of progressively smaller feathers were attached to the structure around the edge of the facial plate. Holes were drilled behind the eye sockets to facilitate subsequent soldering.

The facial disc was constructed out of a single sheet of copper, beaten into two shallow cups. The edges were incised with tin-snips to simulate the frill of short, stiff feathers, which gives the face its character. The frill was given depth by making two hollow collars which slip behind the disc, and were also incised around the edges. After trialling a number of designs, it became clear that it was not possible to express in copper the filigree structure of all the facial feathers, and a compromise including the beak was selected.

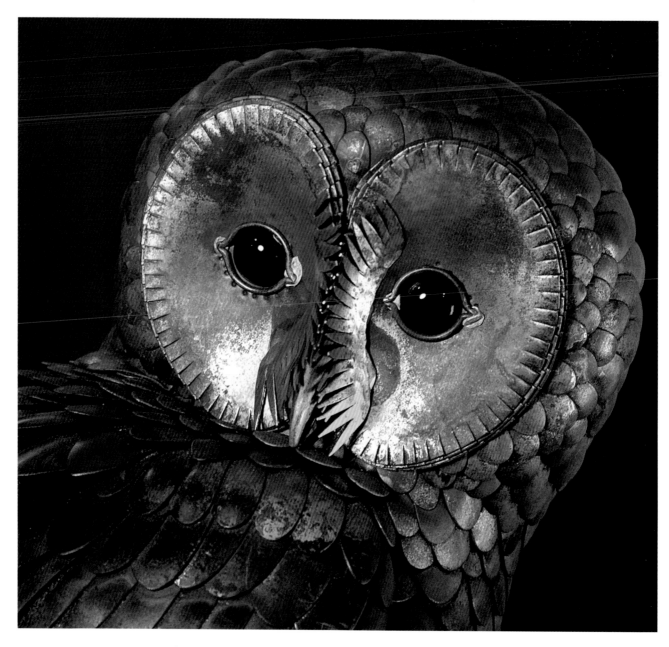

The feathers that divide the facial disc and cover the nostrils and beak are, in nature, fine and filamentous. After several attempts, these simple frills were made to represent them. In this photograph, they are held in temporary position by plasticine, as are the eyes and sockets, to check the overall suitability of the feathers.

The face, including the beak, wire eye sockets and facial feathers, was assembled, soldered into position on the facial disc and the completed face soldered to the facial plate. The eye stones were not attached until later.

CLEANING, COLOURING AND POLISHING

The process of removing surface deposits of copper oxide that build up on the copper plates has been described in earlier chapters. However, this is a comparatively large piece, with each feather requiring individual treatment. The use of a rotating circular wire brush mounted on the end of a flexible drive considerably reduces the work required, but it is crucial that the rotation of the brush is with the direction of the feathering not 'against the grain'.

Small grindstones were used in awkward or relatively inaccessible places, in this case the face (right).

The bright copper colour revealed by wire brushing is not the final colour desired and the sculpture needs 'toning down'.

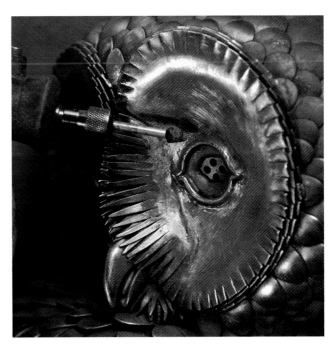

Small, intricate or lineal features are best cleaned with a small grindstone.

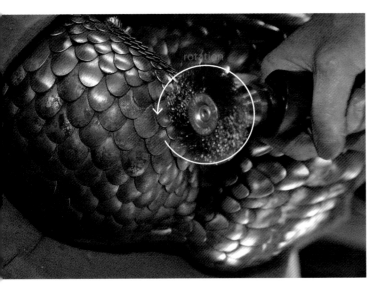

Before the piece can be coloured, the build-up of copper oxides on each feather needs to be removed. Although these oxides can be chemically dissolved, it is probably easier and safer to clean each feather mechanically. Take care not to damage the piece and wear gloves and a face mask for protection.

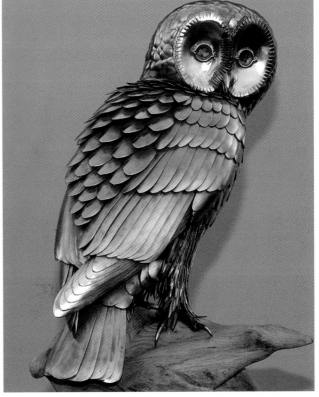

Cleaning leaves the piece looking bright but raw.

This toning-down process is achieved by heating the copper (see Chapter 5, p. 88). However, the presence of copper sheet of varying thickness in the owl creates problems not encountered when working on the fish, and the colouring of the owl is thus considered in some detail here.

Colouring was started at the areas of thickest copper, namely the tail and the wing primaries (thicker sheet was used here to support the bird when it is carried). The other feathers respond to gradual heat, turning red, through blue to the desired bronze/brown.

Colouring the face presented problems. The fine, thin feathers heated up to the point of colour change much sooner than the thick, multi-layered copper on the facial disc. Thus, the former reached its selected colour much sooner than the latter, and there was a risk that these feathers might melt so care was taken not to overheat them. The transformation from a bright copper to a burnished bronze was complete. The final tasks were to glue in the eye stones, wax the entire sculpture and, finally, fit it to its wooden base. Thus, a few scraps of recycled copper are formed into a new, vibrant being.

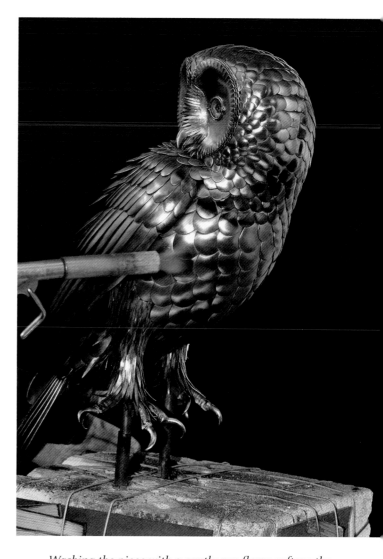

Washing the piece with a gentle gas flame softens the rawness by inducing the controlled production of copper oxides on the surface of the metal, whose colour will alter with the heat applied. The objective here was to achieve a relatively uniform bronze colour, which is evident here on the breast and belly but not yet on the head and neck where the reds and blues are transitional.

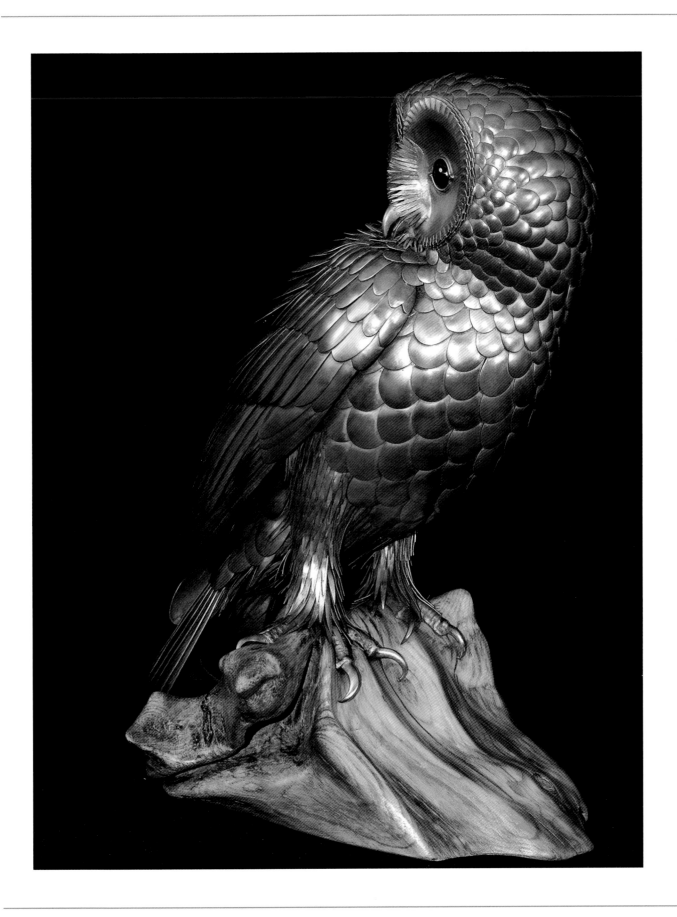

Gallery

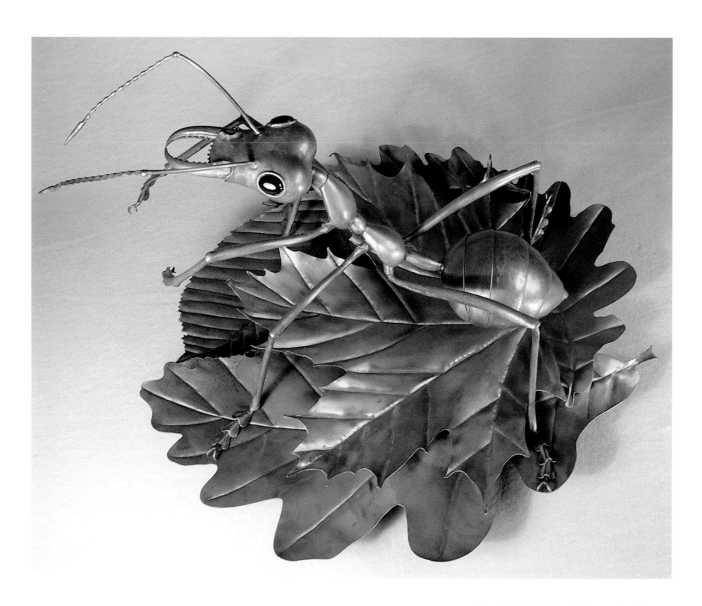

Sue White-Oakes, 'Weaver Ant', 2009.
Copper, width: 46 cm (18 in.).
Photo: courtesy of the artist.

INTRODUCTION

This final chapter introduces you to the work of other contemporary artists who have chosen to work in copper, making figurative sculptures that are very different to those of Sue White-Oakes' illustrated so far in this book. We have also included a small selection of Sue's work in this chapter, so that you can see the wide variety of subjects that she has tackled over the past 25 years.

In addition to the virtues of working in copper *per se* (which we have attempted to describe), such as its malleability, stability and forgiving nature, it is also a material well suited for exposure outside since it does not rust. It is thus commonly used for garden art.

We asked each artist to contribute a few thoughts on their work and on themselves. This is a summary of what they said.

VALERIE BOON

Valerie works in London: 'For my sculptures I use pyro, which is copper electric cable enclosing copper wires. Pyro varies in thickness and is fairly flexible. To begin a piece, I form the basic structure and then build outwards, soldering the joins using a gas cylinder and plumber's solder.'

If you would like to know more, contact her at valeriejboon@aol.com.

MICHAEL BREWER

Michael was born in 1933 in Northampton: 'Art in various forms was always present as a hobby until 1978 when I started sculpting figures in clay, mostly birds ... In 1986, I attended a welding course and made a life-sized heron in mild steel and brass, which won first prize at "Weldex 87". From then on, I have made and sold many more sculptures, mostly in steel but also in copper and brass. I now make things for my own amusement, or as gifts for friends.'

MICHAEL KUSZ

Michael's studio is near Richmond, Yorkshire: 'Copper is a fantastic forgiving material with a beautiful array of naturally oxidised finishes. It will bend and shrink to follow any whim. It can be punched, shaped, cast, electro-deposited and coloured in a myriad of ways. I'm still scratching at the surface of what I could do with it. I only regret not discovering it earlier.

'Using both artistic and engineering skills, I transform scrap materials (anything from old boilers to antique garden rollers) into unusual, often humorous numbered works of art for enjoyment both indoors and out. My work features in public and private collections internationally.'

See www.graculus.co.uk.

THRUSSELL AND THRUSSELL

Gary Thrussell and his son Thomas produce public art and their own collections of organic sculptures, working from studios in the heart of Bodmin Moor: 'We work in mild steel, copper and stainless steel using forging, welding and sheet metalworking processes. We enjoy pushing the boundaries of the materials we use, exploring new ideas and methods.

'Much of the inspiration for the work we produce is based on the natural world: many of our sculptures represent the insect and plant world, whereas some of the public sculptures often have a historical content but still draw from the organic side.

'Our work can be found nationwide in the towns of Brentwood, Braintree, Bodmin, Basingstoke, Colchester, Camborne, Coventry, Halstead, Maldon, St Austell and Saltash, in public spaces from the Natural History Museum to the Eden Project cycle trail. The largest piece is in Brentwood town centre, just east of London, and we have recently completed two large insects for Basingstoke council.'

See www.thrussellandthrussell.com.

Sue White-Oakes, 'Octopus', 1993.
Copper, 80 x 155 cm (31½ x 61 in.).
Photo: courtesy of the artist.

Michael Kusz, 'Rook's Nest', 2008.
Electroformed copper and barbed wire, width: 75 cm (29½ in.).
Photo: courtesy of the artist.

Valerie Boon, 'Sheep', 1998.
Copper (pyro electric cable), 71 x 107 cm (28 x 42 in.).
Photo: courtesy of the artist.

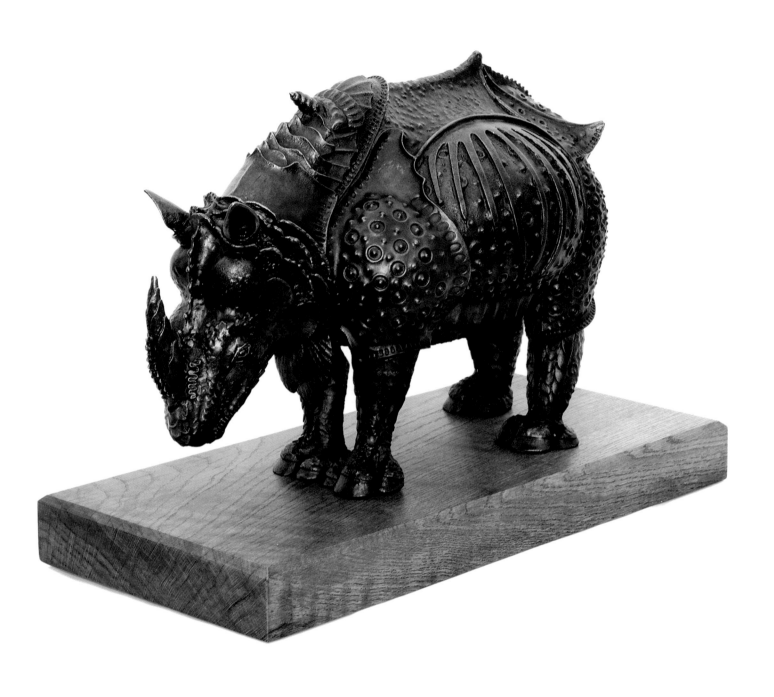

Sue White-Oakes, 'Rhinoceros after Dürer', 1997.
Bronze cast from a copper original, 45 cm (17¾ in.).
Photo: courtesy of the artist.

Michael Brewer, 'Frog', 2007.
Copper, height: 35 cm (13¾ in.).
Photo: courtesy of the artist.

Sue White-Oakes, 'Capercaille', 1995.
Copper, 60 cm (23½ in.).
Photo: courtesy of the artist.'

Thrussell and Thrussell, 'Centipede', 2008.
Copper and rusty steel, 2.5 m (8 ft 2 in.).
Photo: courtesy of the artist.

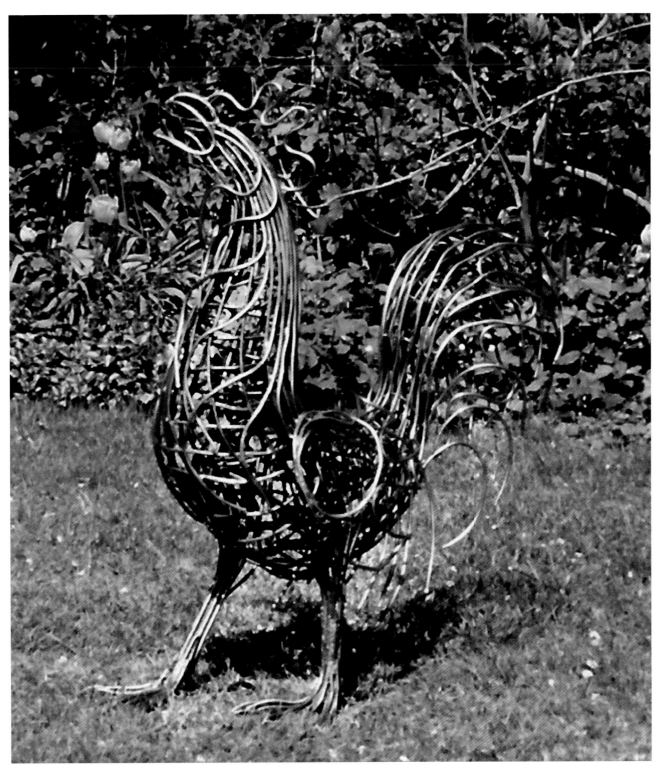

Valerie Boon, 'Cockerel', 2004.
Copper (pyro electric cable), 84 x 74 cm (33 x 29 in.).
Photo: courtesy of the artist.

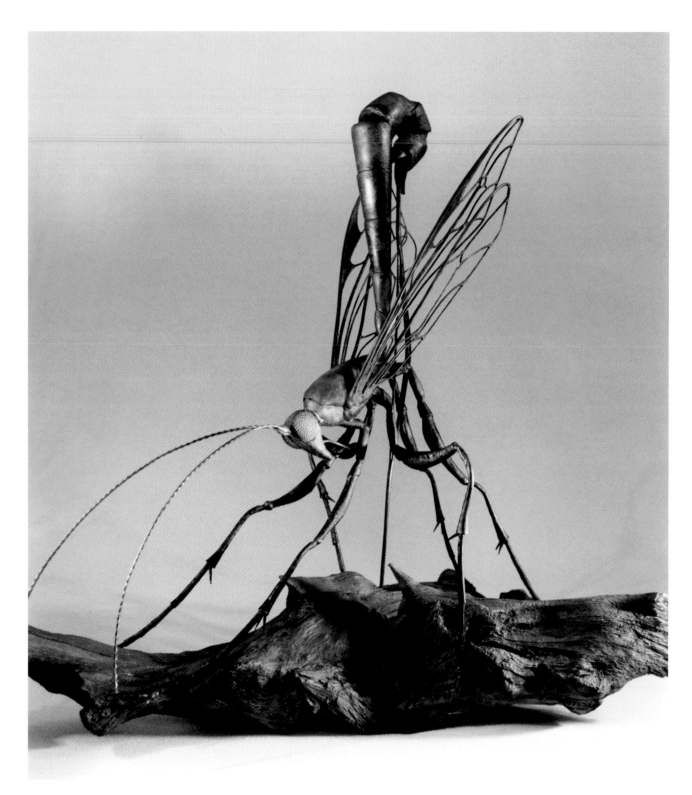

Sue White-Oakes, 'Ichneumon Wasp', 1990.
Copper, 56 cm (22 in.).
Photo: courtesy of the artist.

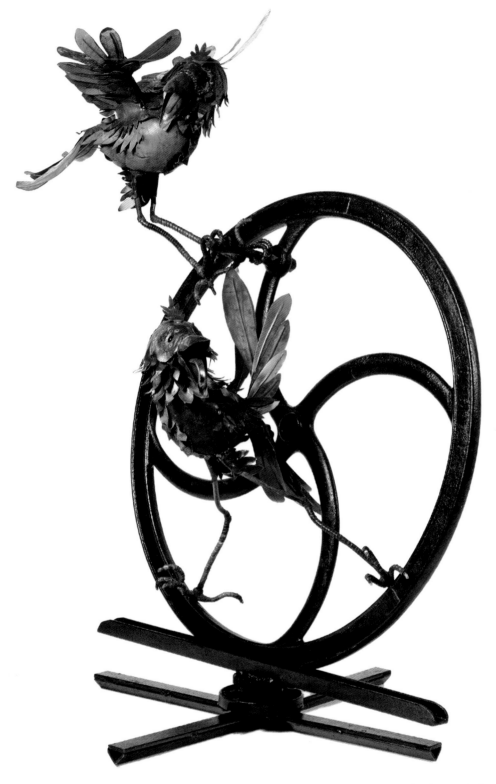

Michael Kusz, 'Wheel of Life', 2010.
Iron and copper, 180 cm (5 ft 11 in.).
Photo: courtesy of the artist.

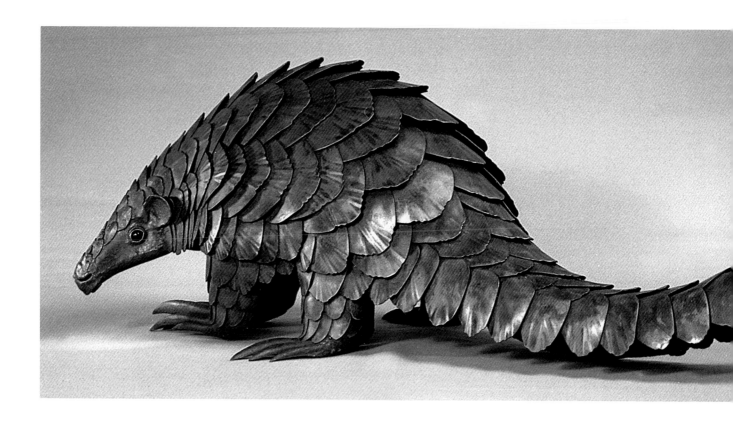

Sue White-Oakes, 'Cape Pangolin', 2008.
Copper, 84 x 26 cm (33 x 10 in.).
Photo: courtesy of the artist.

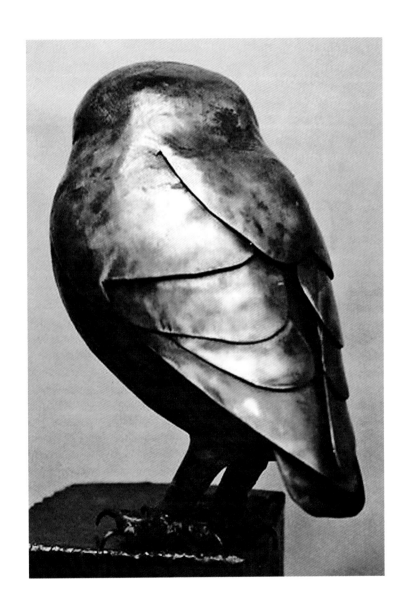

Michael Brewer, 'Little Owl', 1997.
Copper and steel, height: 15 cm (6 in.).
Photo: courtesy of the artist.

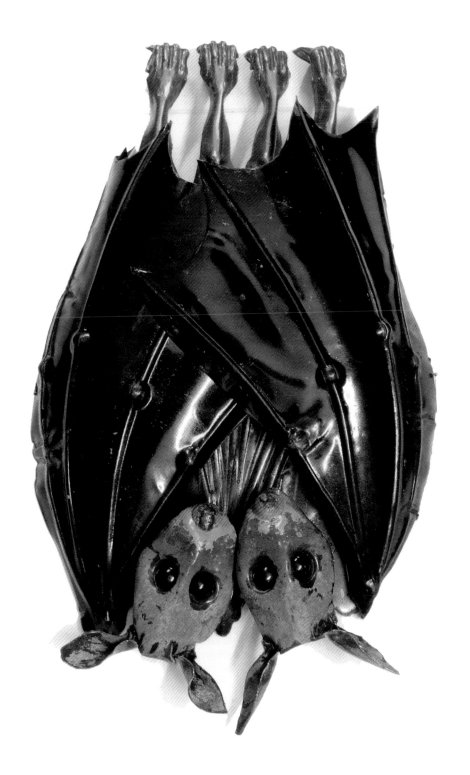

Michael Kusz, 'Love Bats', 2007.
Copper, 28 cm (11 in.).
Photo: courtesy of the artist.

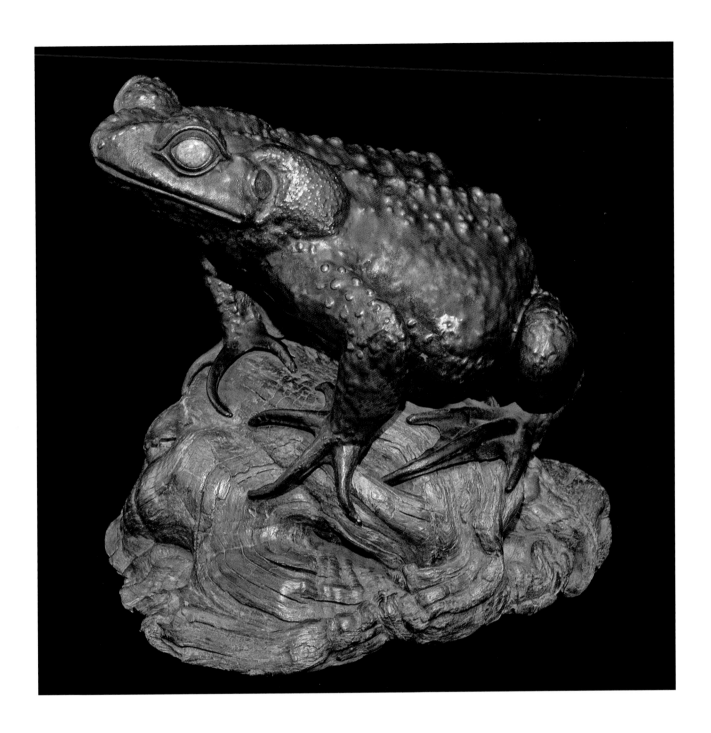

Sue White-Oakes, 'Common Toad on Oak Burr', 1989.
Copper, 33 x 43 cm (13 x 17 in.).
Photo: courtesy of the artist.

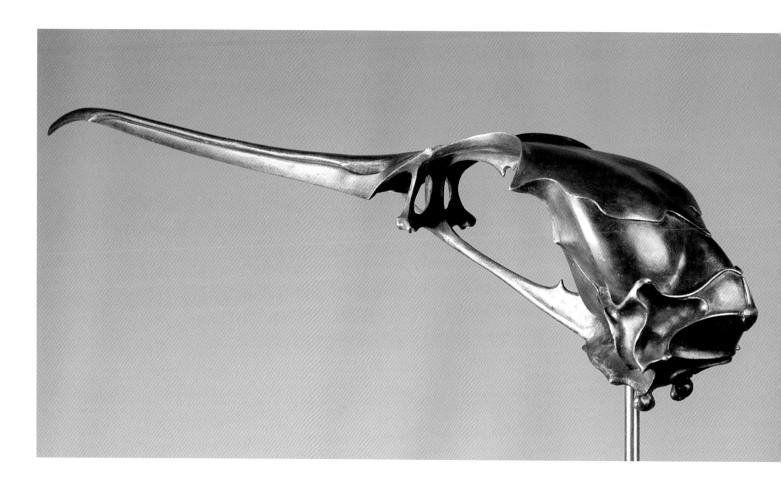

Sue White-Oakes, 'Cormorant's Skull', 1994.
Bronze cast from a copper original, 60 cm (23½ in.).
Photo: courtesy of the artist.

Thrussell and Thrussell, 'Parrot', 2010.
Copper and stainless steel, 1.9 m (6 ft 3 in.).
Photo: courtesy of the artist.

Glossary

ANNEALING The process of softening metal by heating it, then cooling it.

ANVILS Metal or wood blocks, bars or tubes on which metal can be hammered and formed.

BOSSING MALLET A mallet with a tapered head; one face has a large domed head and the other a smaller domed head.

CABOCHON A smooth, domed, semi-precious stone.

CHASING TOOLS Steel punches with shaped ends used for creating texture on a metal surface.

FLUX A paste or liquid applied to the surface of metal to be soldered, to prevent oxidation and assist the flow of the solder.

HACKSAW General purpose saw, with replaceable blades, for cutting metal.

HARD SOLDERING Joining metal by soldering using a filler rod of an alloy of copper, silver and zinc, where a high degree of heat is needed.

MALLEABLE Metal or other material that can be worked and shaped easily.

MANDREL A shaped piece of metal or wood around which sheet metal can be formed by hammering or bending.

PIEN One side of a hammer head that is round or wedge-shaped.

PIERCING SAW A fine saw, with replaceable blades, for cutting intricate shapes out of sheet metal.

PLANISHING A process of smoothing by hammering using a very polished, slightly convex-headed hammer, designed to remove the various bumps and dents left by other tools.

PUNCH A metal rod with a shaped end used for applying texture to the surface of metal.

QUENCHING Cooling hot metal by plunging it into cold water or pouring cold water over it.

RAISING Producing a dish shape in sheet metal using various hammers and anvils.

REPOUSSÉ Creating a decorative relief pattern on sheet metal by working from the reverse side.

SWAGING Using a tool to shape or manipulate metal by pressure.

TEMPLATE A trial pattern cut from card or paper that can be used for marking out shapes.

WORK-HARDENING Metal becomes work-hard after being hammered, bent or otherwise deformed. It then requires annealing to soften it again.

Suppliers

Axminister Tools
0800 371 822
www.axminster.co.uk

Buck and Hickman (tools)
08450 510 150
www.buckandhickman.com

Bullfinch (gas torches)
0121 765 2000
www.bullfinch-gas.co.uk

Copper development (UK Copper
Board)
www.ukcopperboard.co.uk

Dustmasks Direct
01842 765634
www.dustmasksdirect.co.uk

European Copper Institute
www.eurocopper.org

Johnson Matthey Metal Joining
(solder)
01763 253200
www.jm-metaljoining.com

Kilnlinings (kiln bricks)
53 Ennerdale Close
Dronfield, Derbyshire
S18 8PL
www.kilnlinings.co.uk

Machine Mart (tools)
0844 880 1250
www.machinemart.co.uk

Moldex – Metric (UK) (face/dust
masks)
0115 985 4288
www.moldex-europe.com/en

Screwfix (tools)
0500 41 41 41
www.screwfix.com

Index